that if I prayed two acts of contrition instead of one then that would double my protection—even as a kid I was already covering all my bases!

I wanted to be a journalist. In my late teens I began working as a reporter in Dili, the capital, for a local newspaper, *The Voice of Timor*. I managed to get an extra job in radio presenting news, and a part-time job on Portuguese television, where I started to shoot news stories for them, and, afterwards, wrote the news myself. In the process, I became very pro-independence, very critical of the Portuguese colonial rule. (No offense to the Portuguese today who have done an outstanding job for East Timor. But the colonial Portuguese pre-1975 were so incompetent and lazy and did nothing to really develop the country.)

When I was only twenty I started working at the tourist information department, and made some outrageous remarks while having drinks with two guys, one from the U.S. The next day I was called in by the Portuguese political security police, the famous PIDE, notorious in Portugal and Africa for using torture against civilians. They repeated everything that I had said about them. I was impressed. Two days later I was again interrogated, for hours, lost my job, and left for Mozambique for two years. They did not torture me—just interrogated me and I left. I don't want to pretend that I was a hero. If I were not drunk, I would not have said what I said. That was my defense, also. To which they said, "It doesn't matter. You thought it. You actually believe it."

In 1974 I founded the first social democratic party in this country, which, within weeks, became the most popular, practically a revolutionary front for an independent East Timor. Some Marxist students who had just returned from

Portugal joined and took control. That is where it got its reputation as a Marxist-Communist organization. But it was never a Marxist group. It just had a lot of rhetoric in speeches. We used to call each other "Comrade," do stupid things, like salute with the clenched fist (why not just wave?).

And then in 1975 came a civil war. The Portuguese left and the city was like a ghost town. FRETILIN (Revolutionary Front for an Independent East Timor) was in control. Not one single house had been destroyed. Not one single thing was damaged. The Portuguese bank was intact. Even the cars that belonged to the Portuguese government were untouched. The Mercedes of the governor was not touched. There was respect, but the town was deserted. Thousands had fled. The war had ended. I did not see it because I was in Australia during the brief period of the civil war which lasted about two weeks. But when I came back I saw the consequences of the war, brief but vicious and stupid.

Then came the invasion on December 7, 1975. In November 1975 I was made foreign minister and on December 4, I was sent out of the country. A light aircraft came to take me to Australia and then on to Europe and the U.S. I arrived in New York two days after the invasion, which took place on December 7 when I was mid-air between Asia and Europe. Two days later I was on my way to New York to plead the case of East Timor at the United Nations.

I arrived in New York in the midst of the North American winter. I had never been to a major city in my life and had never seen snow. My task as the newly appointed minister of foreign affairs of East Timor was to plead our case before the UN. I was lucky to have been helped by the newly independent

> "Five thousand young people went from a church to a cemetery to pay tribute to a young Timorese student…shot inside the church by the Indonesian army. It was a very peaceful procession. Suddenly Indonesian special troops arrived with machine guns and started shooting at the people."

nation of Mozambique. They set up appointments for me and introduced me to the members of the Security Council. At the age of twenty-five I was probably the youngest foreign minister ever, certainly the youngest ever to address the Security Council. Along with the first two factors is the reality that I was the least experienced and most naive. So when I say I was the youngest it was not necessarily as a tribute but a defense. And though Indonesia was a powerful regional leader, courted by the U.S. in the post-Vietnam, anti-Communist, Cold War world, we managed a stunning unanimous decision in the Security Council. But that was also my first lesson in international hypocrisy. The same countries that voted to condemn the invasion and demand that Indonesia withdraw were the same ones selling weapons to Indonesia, enabling Indonesia to pursue the war in East Timor for the next twenty-three years.

The only country that gave us money at that time was Mozambique. By 1981 they were broke, so Angola, which had a bit more money, although at war, supported me with sometimes five hundred dollars a month, or one thousand dollars a month. That was how I survived. I lived mostly in run-down sublets of friends or of people I knew. Occasionally I would do translations for a friend of mine who worked with a church, translating funding requests from Portuguese, French, and Spanish, at ten dollars a page. And if I double-spaced them, she didn't mind. Later I had a full-time job for the Mozambique government in Washington as an advisor on American politics, media, and congressional relations. In 1988, I went to Oxford as a senior fellow. After that I moved to Australia. The late seventies were the darkest years in East Timor's history: 200,000 people died because of weapons sold by the Americans. My own sister Maria was killed by a plane delivered to Indonesia two weeks before by the Carter administration. Those planes caused huge devastation in East Timor—my two brothers were also among the thousands killed. By the end of 1976–77, the Indonesian army was at a standstill. Because they never had a truly professional, disciplined army, they never expected such a huge resistance. They took thousands of casualties. If the U.S. had not intervened massively the Indonesian army probably would have been defeated militarily by the Timorese resistance force. So the Carter policy made a difference with a massive injection of weapons to Indonesia that changed the balance of power and prolonged the war for twenty years.

I'm not sure of what kept me going in those dark decades. Some people fight because they believe in world revolution. But I am not an ideological person and I don't believe in world Marxism. Nor am I a fundamentalist Catholic who believes in the dominance of the faith. Instead I thought of the spirits of those in East Timor, telling me to fight on. I was totally isolated in the U.S. and could have gone and taken a job, like so many exiles do, defected and gotten on with my life. Instead I worked on the cause of East Timor as a full-time job, twenty-four hours a day almost. I had no money but I would get in the bus and go anywhere in the U.S. to talk. I got an invitation to go to Milwaukee—I went and spoke there. A friend of mine had the brilliant idea that I should speak in Birmingham—so I took the bus there and found an audience of twelve Eritreans listening to me. One day I went all the way to Chicago because a very kind activist managed to get my name included in a big conference in a fancy hotel. Sharing the talk with me was a university professor with a very loud voice, Roger Clark of Rutgers University. There were all old ladies in the audience, most of them half-asleep. I was so polite I didn't want to wake them, so I talked softly. When it was the professor's turn, I wondered whether the ladies would have a heart attack. He definitely woke them up.

On November 12, 1991, five thousand young people went from a church to a cemetery to pay tribute to a young Timorese student who died two weeks earlier, shot inside the church by the Indonesian army. It was a very peaceful procession. Suddenly Indonesian special troops arrived with machine guns and started shooting at the people. At least five hundred died that particular day. Many were killed in hospitals by Indonesian doctors in collaboration with the army: poisoned with toxic pills, their skulls crushed with rocks. We had witnesses. Two of them (both paramedics) survived and escaped. One of them took samples of the pill given to people. Those pills were tested by forensic experts in London and found to be a highly toxic substance usually mixed with water to clean toilets. There were soon many more massacres. The difference between this one and the others is that an incredibly courageous British cameraman was there and filmed the whole massacre. As the Indonesians kept firing, he kept filming and when they stopped, he took out the tape and buried it in the cemetery. They took away some of the pictures he had left, and that night he climbed back into the cemetery to recover the film and smuggle it out of the country. He was lucky he was a foreigner and the Indonesian army was careful not to harm him. But after this things began to change greatly.

In December 1996 Bishop Belo and myself received the Nobel Peace Prize, which gave me easy access to international media and world government leaders. As you can understand, Indonesia was not too terribly pleased. I then became the target of a vicious campaign of innuendoes and physical threats—even death threats.

The citation was for more than twenty years of work, and for a peace plan which was based on a step-by-step resolution, strikingly similar to the Israeli-Palestinian Oslo peace accord which came out later. If the Indonesians had accepted it, war would have ended without further destruction and killings. Indonesia would still be here in an honorable way and East Timor would be enjoying a period of autonomy within Indonesia. A referendum would have been held at the end of twelve years from the day of signing. The problem is I was dealing with a dictatorship that does not understand that dialogue, concessions, and flexibility allow all sides to win. The military only understands the "we win" concept.

In spite of the relentless campaign of intimidation and bribery that went on for months, well over 90 percent of East Timor voted for independence. And according to internal UN sources an additional 6 percent of the votes were stolen through fraudulent ballot counting. Then came the violence. It was orchestrated. It was planned in minute detail over many months. Almost every town in East Timor was destroyed, almost every house. Not only of the rich, or the better off, but humble homes of the peasants, homes made of grass and thatch, all burned down. In one of the most unprecedented phenomena in modern history at least one-third of the population of the country was abducted at gunpoint and taken to another country via transport ship. My oldest sister (whom I had not seen in almost thirty years) was taken in a warship to Indonesia with her children. There are still over a hundred thousand of our citizens in West Timor camps. The repression was organized by an army with infrastructure, with money, with power. Two-thirds of the militias were from Indonesia (not East Timorese). This kind of violence was done by people alien to this society. Timorese who were part of the militias have surrendered saying they were given alcohol and totally possessed. There were hundreds of Indonesian police disguised as militia in the midst of shootings. But later they removed the disguises, and the army operated in uniform. My nieces who live on the south coast

> "It was the people who went to the phones, to the Internet, to the fax machines, sending a barrage of messages into Bill Clinton's office, to the U.S. State Department, to Tony Blair and Robin Cook in London, and to the French that made peace happen."

said there were never any militia there; instead it was the army burning things, because there were no journalists there—why bother hiding?

Meanwhile, during this bloodbath, I tell you, I was so sad, so alone. I had to handle hundreds of phone calls every day. I went to Washington and met with senators Patrick Leahy, and Tom Harkin, and people in the State Department like Thomas Pickering. I spoke at the National Press Club, and appeared on program after program for NBC, ABC, *Night Line*, and CNN—who were fantastic; I was on CNN constantly.

Hundreds of thousands of people made phone calls and sent Internet messages. And the tide began to change. At one point I thought if I didn't get the peacekeepers into East Timor, I would have failed. And I did not know what I would do with the rest of my life. I felt I betrayed the people, who trusted me, and because they trusted me, they took risks. I was constantly on the phone with people underground. Even in the worst times their phone was still working. I was on the phone to a Catholic priest, a great Jesuit priest. As the shooting was taking place he was under cover inside the house. I could hear on the phone cars driving by, killing, shooting. And he said, "I don't know if I will be alive a half hour from now." I tried to get the UN people to rescue him but even they did not feel safe. My own sister suddenly disappeared. But fortunately she and her family were next door to the UN and they managed just to jump the fence and enter the UN compound. I was in New Zealand attending the APEC summit when I heard President Clinton live from Washington say that Indonesia must invite the international community to intervene. And two days later the Indonesians did. Two days after that, I finally met President Clinton. Now meeting the most powerful man in the world was incredibly reassuring to all

Timorese, because once the president of the U.S. makes a decision, it's done. And Clinton was so personable, so charming, you feel totally at ease—and he asked pointed, informed questions. Much more intelligent than most journalists ask. That evening I phoned Xanana, the Resistance leader under house arrest in Jakarta, saying I had met with the president of the U.S. and was confident the peacekeeping forces would arrive soon—and so they did.

This turn of events was totally unprecedented for Indonesia. They were so used to crushing every opposition voice, peaceful demonstration, every dissident, to seeing their army as invincible—yet for the first time in history they were defeated. Scholars claimed they had never lost a battle though they failed to explain that the battles were against civilians. It showed the power of public opinion. Because it was the people who went to the phones, to the Internet, to the fax machines, sending a barrage of messages into Bill Clinton's office, to the U.S. State Department, to Tony Blair and Robin Cook in London, and to the French that made peace happen. In Australia tens of thousands were demonstrating. In Portugal over a million people demonstrated. And that made Clinton lead a charge to rescue the people of East Timor, and also showed that when the U.S. wants to use its power effectively for good, it can prevail. I am prepared to forgive the U.S. all sins of the past after this courageous leadership by Clinton.

Now you say this victory took courage, but I think more courage is required to be humble, to admit your mistakes, your sins, to be honest. More courage is required to forgive than is required to take up arms. Which means that I am not the most courageous person in the world. Because after all, courage is easier said than done.

KOIGI WA WAMWERE

KENYA

POLITICAL RIGHTS

"I was put in the basement police cells and woke up in a sea
of water. I was naked and had been sitting in it all night. I stayed
in that water for about one month."

Koigi wa Wamwere is one of Kenya's best-known political prisoners. Author of several books, plays, and poetry, wa Wamwere was born to a poor family in a forest community, did well in school, and was awarded a scholarship to study at Cornell University, where he graduated in 1973. He returned to Kenya to work for democratic reforms, running for parliament in 1974, until his criticism of the Kenyan president and his government led to wa Wamwere's arrest in 1975. He was held with no charges, no judge, and no jury for three years. Released in December 1978, in 1979 he again ran for parliament and won. He served a poor rural district for the next three years. From August 1982 until December 1984, wa Wamwere was again held in prison without charges. In June 1986, he sought exile in Norway. On a visit to Uganda in 1990, Kenya's security forces crossed the international border, kidnapped wa Wamwere and detained him until 1993. Again he fled into exile. And again he returned to Kenya, where this time he was arrested on trumped-up charges that carried the death penalty. He was released on December 13, 1996, after domestic and international pressure on the government, to seek a treatment abroad for a heart condition. Wa Wamwere received a show trial and was sentenced in 1995 to four years in prison and six lashes with a cane. His lifetime of unrelenting activism for democracy and nonviolence has meant detention, torture, and imprisonment for much of his adult life. He has emerged from those experiences with a wisdom and a sense of peace almost beyond imagination.

Human rights work is actually a struggle to preserve life, one I have been involved in for a long time. Consciously, I got involved in the struggle for human rights as a struggle for democratic rights, since initially I saw human rights as the cornerstone of democratic freedoms.

As a student at Cornell University in 1971 I began asking why Kenya couldn't have those basic freedoms. I saw American life was a lot more open, that people could criticize their president and demonstrate openly. I encountered the writings and speeches of Martin Luther King, of Robert Kennedy and his brother John F. Kennedy, and those of Malcolm X. They inspired me to fight; they completely changed my life—completely. I had gone to Cornell to study hotel management, but I instead learned about the struggle for human rights. Once that dream was implanted in my mind, I could not do anything but pack my bags and return home to start what was going to turn out to be a long struggle.

When I returned to Nairobi in February 1973, Jomo Kenyatta was still president and calling for his ouster was tantamount to suicide. Nevertheless, I started saying openly that things in my country were not going the right way. It was a shock for people at home to hear me speaking critically and overtly about what was going on. I was lucky to have the support of my brother, and we very quickly put together a team of five young men who shared our dreams of respect for human rights, equality, and an end to corruption. We did not know how to go about the fight, where to start. And I decided that the most definite means of exposing the problems was through the press. So I became a freelance journalist. I had a feature article every week, and each time I published, the police would come and take me to the police station and have me interrogated. People thought that what I was doing was sheer madness. The police would take me to the station, interrogate me, charge me, and then I would be taken to court. Then most of these cases would get thrown out. They would

ask me to go home. I wonder what gave me the strength to go on; I guess the dream that I dreamt was so strong that it gave me a lot of energy to continue.

One article I wrote that attracted a lot of attention dealt with working conditions for forest workers. I was born and raised in a forest area, and my father and mother were forest workers, so I knew what I was talking about. It compared the treatment of forest workers in Kenya with similar workers in Tanzania. When the British were the colonial power here, all the workers between Kenya and Tanzania were treated more or less the same because the administration was identical. But after independence the Tanzanians were suddenly able to move forward whereas Kenyans remained just where they were. Besides writing, I went out and photographed the housing. The exposure of these working conditions made the government so angry. One well-known official in the government, Secretary Shamala, said I should pack and move to Tanzania. (Years later, however, he defended me in my treason case.)

In another attention-getting piece, I wrote about tribalism as a part of the ideology of exploitation. Again, it made people very angry. It seemed wrong the way the government was discriminating against certain tribes while allowing others to feel the government belongs to them exclusively, but that point of view meant I was called a traitor. I then wrote about corruption in government-controlled companies, a major issue. What was happening was that people would collect money from peasants promising that they would buy land for them, and, in one typical instance, bought a big farm, only to afterwards throw the people out and keep the farm to themselves. And so I wrote about it.

Sometimes, I was risking my life to write about these things, but I wasn't thinking of it as a risk. After a while, though, things got worse. I had to go into exile at one point, because the threats were serious. And even while I was in exile (in Norway at this point) they sent people to try and assassinate me.

The first time they sent two people, an Italian and the son of a Malian diplomat in Nairobi. They were searched in Sweden after the train crossed the border and the Italian's gun was discovered so he was detained. The second hit man managed to make it to the Oslo train station. He had been given a Kenyan-Somali contact, but all Somalis looked the same to him, so the first Somali he saw he called over and said, "Here are the goods." The Somali thought the package was a kind of leaf that we chew to stay awake. But when he opened it, he saw it was a G-3 rifle with four hundred rounds of ammunition. He got the shock of his life. So he called the police. Then that man got arrested and finally confessed that he had been sent to come and kill me.

A little later they asked someone to hijack a plane I was taking from London to Tanzania. The man demanded to know, "What is my protection? What happens

"Life is a permanent struggle between good and evil. In this struggle there isn't room for neutrality. I couldn't possibly see myself crossing the floor to the other side. I could never be at peace with myself. I would rather die."

after the hijacking?" And they really couldn't guarantee him anything. Strange, because when he first told me this story, I dismissed him. But then I realized he was telling the truth and I got the Norwegian police involved. We bugged my living room, then I invited him home to talk about it and be photographed by TV people. I said, "I think you are lying about all these stories," and he said, "How can I prove I am not?" I told him, "Let's go to the police and report this." He said, "Let's go to the commissioner of police." He told the commissioner, "Look, if you don't believe me I'll call the State House in Kenya." So he called and the operator knew him and put him right through. There was no way that kind of internal State House telephone transfer would have been made if they didn't know him very well. It became a big diplomatic incident.

Another time they sent somebody who pretended to be a bishop. He said he was the former chairman of the National Christian Council in exile and dressed exactly the part. He really fooled me. At home we did not eat without saying prayers. He would say prayers, which made me very embarrassed when I found out he was a fake. At one point I asked him to speak to the BBC about relations in Kenya and after the interview was broadcast the BBC called me. They said, "This isn't Bishop X; the real bishop is complaining!" He ended up confessing, saying he had been sent by the State House and giving us numbers of his contacts there. These were direct numbers to the president. It turned out he had been promised three million shillings if he could assassinate or kidnap me.

Another time, when I went to Uganda to visit, I tried to contact people at home. During the day I came out of the hotel in a town which straddles the Uganda and the Kenya side of the border, and I didn't know that security people go back and forth. That time I was in the company of somebody who actually, I think, sold me out.

I remember the day I was captured. It was July 1990. I noticed some people at the table, especially one woman who definitely looked Kenyan, looking at me. (Eastern Ugandans and the Eastern Kenyans have a complexion that is slightly different; Ugandans are darker.) Anyway, not a local person. I asked the innkeeper if Kenyans came there and I was told they did, so I decided to go back into the room. Later that night about five people, all masked, captured me. I never knew who they were. They kidnapped me from Uganda and brought me to Kenya. They first put me in prison, then went around to arrest my friends. My brothers were arrested and we all were charged with treason. One thing I didn't understand was why they didn't kill me. I was put in the basement police cells and woke up in a sea of water. I was naked and had been sitting in it all night. I stayed in that water for about one month. About a foot of water goes into the basement cell. They could freeze that water, make it so cold that you froze and shivered uncontrollably, and then make it so hot you felt like suffocating. The changes in temperature gave me a lot of pain. Of course they didn't give me

food. I was only given something to drink when I was under interrogation. I spent a month alone in isolation. I was interrogated during the day. They threatened to throw me off the roof. It was very scary.

I was brought before this panel at one point and one of the men stood up and said, "Now you know we have you in our hands," and I just said, "Yes." He said, "Do you accept that we are stronger than you?" I said, "Yes, but only to the extent that you have the police, the army, and all this. But my ideas are stronger than yours. What I am fighting for is greater than what you are trying to protect, so I don't accept you as my master." He said, "Look, I'll give you a deal. I am stretching out my hand to you; if you shake my hand you can go home. If you can't beat them, join them. That is what we are offering you. Shake my hand and you can go home with all your friends that are here." He put his hand forward and I said, "No." He said, "In that case you have to die." So I was blindfolded and handcuffed and returned to the cell. He said, "In a few days you will be taken to court and charged with treason."

Why didn't I shake his hand? Because of my conviction that if I tried to make peace with these people it would be like making peace with the devil. Life is a permanent struggle between good and evil. In this struggle there isn't room for neutrality. I couldn't possibly see myself crossing the floor to the other side. I could never be at peace with myself. I would rather die.

My mother went around the country trying to find a lawyer to defend me and only Shamala would do it. It was very, very brave of him to agree; and eventually we were released.

In 1975, they rounded us up and detained us without trial. I stayed in prison until December 1978. Then I came out and ran for parliament from a constituency that needed someone to speak for the poor. President Moi then invited me for breakfast. Initially, he spoke well of me and, because he sounded like a person who wanted to make a break with Kenya's past, I thought highly of him. I didn't know it wasn't going to last until we went to a rally somewhere and on the way back I remember very clearly people lining the road shouting, "Joshua! Joshua! Joshua!" Two days later, the president invited Jane, my wife, and me, for breakfast. He started telling me that he didn't want me talking on behalf of the dispossessed and I should stop asking for better land distribution and for repeal of detention. He said, "Let sleeping dogs lie or you will be the one to lie." I told him I understood the threat. He said to take his advice or I wouldn't get far.

Then I asked him if he remembered the meeting when people called him "Joshua." He pretended not to know what that meant. I told him that in Jomo Kenyatta, Kenyans had their Moses, who led them out of Egypt, but instead of taking them to the Promised Land, left them in the desert, when he died. I said, "Now Kenyans look upon you as their Joshua that will take them to the Promised Land. But you cannot take them to the land of milk and honey unless

> "He said, 'Do you accept that we are stronger than you?' I said, "Only to the extent that you have the police, the army. But my ideas are stronger than yours. What I am fighting for is greater than what you are trying to protect….He said, 'In that case you have to die.'"

you give them freedom, unless you give them better wages, unless you give them land." I told him it was necessary to end the corruption. I told him he had led people to believe he would be a Joshua and so he should not let them down.

And again I was in prison, from 1982 until December 1984. I left the country in 1986 and went to Norway until 1990, only to be arrested again in Uganda and in prison until February 1993. I returned to Norway and then went to Kenya that September and was immediately rearrested. This was the time of ethnic clashes, and we had started the National Democratic and Human Rights Organization (NDEHURIO) to fight for human rights, investigate human rights violations, and expose the role of the government in perpetrating ethnic clashes.

At this point, things became tougher. I was having breakfast with my friend and lawyer Gibson Kamau Kuria at his home in Nairobi when we heard on the news that there had been a raid on a police station in a town a few hours away. Gibson said, "If you were in the Rift Valley, you could have been very easily accused of being connected with that raid." One of my friends said they could still do it. Gibson was very angry, since he believed that this was going beyond what they were capable of. But that Friday they did exactly what was predicted: they arrested me for the robbery on the police station, a complete frame-up.

When the police gave evidence against me in the witness box, they would give embarrassed smiles and look down. Some even admitted that their fabrication of the crime was shoddy and ridiculous. A lady in the Danish Embassy wanted to testify that we were together that night, at Gibson's house, but was instructed not to by the Danish Foreign Ministry. There was lots and lots of pressure from the international community, from the Robert F. Kennedy Center for Human Rights to Amnesty International.

But at this point, I had been in prison for two and a half years for treason, detained with charges, but without trial. They had me on death row and it was pretty clear that they were going to find us guilty. This was a classic mistrial. We could not give evidence in court. We could not cross-examine. Our lawyers were not allowed to give summing up arguments. This magistrate was behaving like somebody gone mad—although I sympathized with him because he exhibited a lot of sadness, as though he was being forced to do something he did not want to do. His children, his wife, and even his brother came to see me in the cells. It was a strange thing. Finally this magistrate decided to hand down the death sentence. But just then dictator Moi grew cold feet. You see, I have always felt that there was always some coordination between Moi and military dictator Abacha of Nigeria in their determination to hold onto power and their joint defiance of world opinion against them. But Abacha was always the leader and when world pressure against him in the wake of his execution of the prominent Nigerian writer Ken Sera Wiwa led to sanctions and suspension of Nigeria from the Commonwealth, Moi, the weaker of the two, no longer had the guts to proceed with our executions. And so we got a jail sentence instead of a death sentence. So in a way, like Christ, the condemnation and death of many in Nigeria led to our own redemption.

BISHOP WISSA

RELIGIOUS FREEDOM

"Protecting my people is part of my job. This is what
I am supposed to do. If you were at your house and someone
was beating up your child, wouldn't you stop him?"

*The Coptic (Egyptian Christian) Church traces its roots to Saint Mark, who is believed
to have established it in Alexandria in A.D. 64. Since that time, Copts have been at best
grudgingly tolerated, but often persecuted outright in Egypt. Today, there are nearly
ten million Copts living in Egyptian territory who face frequent harassment at the
hands of state and local authorities. Bishop Wissa's story is a visceral example of con-
tinuous oppression. On August 15, 1998, thirty-five miles north of Luxor, five Muslims
from the village of el-Kosheh allegedly murdered two Christians from their communi-
ty. The police investigating the case went on a rampage, and in the next two months
arrested and imprisoned twelve hundred Christians. More than half of the children,
women, and men arrested reported being tortured, many by beatings, whippings, and
electric shock to ears and genitals. Bishop Wissa witnessed the events in el-Kosheh, his
diocese, and personally interviewed over eight hundred victims. He reported the abus-
es to Egyptian authorities, human rights organizations, and the international commu-
nity. On May 9, 1999, the interior minister dropped the investigation and authorities
then arrested Wissa and charged him with defamation and other criminal offenses.
Bishop Wissa's trial is not yet over, and his courage in speaking out against discrimi-
nation and injustice deserves universal support.*

It was last summer, on August 15, 1998, that two people, both Copts, were killed
and the police started investigating. They started with detentions. Fifty, sixty people
a day, also Copts, were rounded up and held for weeks. Then they tortured people
with all forms of violence. They coerced people to testify falsely. I heard the screams
of people who were being tortured, so I went to meet the prosecutor of the state

security board. I sat with him for an hour explaining all the circumstances in this village. I asked him to conduct legal investigations and to cease detaining and torturing people. But after I left nothing changed.

A week later, the police director in charge of the area arrived. I sent a bishop and two priests to meet him. They had a two-hour meeting; the first hour was very harsh. The police director told them that this area had not seen anything yet. He then realized that the priests and bishop were just as tough on their stand. He became nicer to them and he told them that a man called Michael was the murderer, that he was responsible, and said, "If I were you, I would advise him to go and turn himself in and confess." The police said that the two men who had been killed attacked Michael's daughter, sexually raped her, and she became pregnant. And so the police started torturing all of Michael's family, even his wife, and his youngest child. They took the boy to the desert and left the ten-year-old child there. A few weeks later the girl who had been allegedly raped by these two men came to my office. We had her medically examined and she was a virgin. So we proved that her father was not the killer.

The police then started looking for another killer. But the mass torture continued. They tortured by electricity; by applying electronic shock to sensitive areas, private parts of the body. They hung people upside down from their feet, tied them up as if they were crucified, stomped on them, hit them with sticks or whips. They would take their clothes off and throw cold water on their bodies, even on women. The torture sessions were very bad. I sent many memorandums to human rights groups even though I couldn't explain the depth of the ugliness of the torture. On September 17, the assistant to the minister of interior visited that area called el-Kosheh. He met with all the people who were tortured, taking each case individually. One man walked in. He didn't say anything. He just took off his clothes and showed traces of torture: whips and sticks, bruises. Then the two children, a small boy with his sister, came and described their situation. The sister, one year older than the boy, said that she was electrocuted on her chest and they both started crying.

The assistant to the minister of interior said: "All right, I know the situation now and I will tell the minister." So after that he went to the police and he released Michael Boktor and his two sons. They had spent one month and two days in prison. But to our surprise, they instead charged the cousin of one of the men who was killed. On September 18, fifteen people from the village of el-Kosheh (in the city of Sohâg five hundred miles south of Cairo) who were tortured went to the criminal prosecutor and showed him all their

scars and said they wanted to press charges against the four policemen responsible. The general prosecutor of Sohâg decided to transfer them to the medical examiner and pathologist. Then the medical examiner referred two people who were in critical condition to a bigger place. But nothing happened—in spite of this overwhelming amount of evidence against the police, nobody would prosecute the government. There were many people who wanted to file complaints against the police but they backed off when they realized that no action was taken. This was an incident that stirred up a huge reaction in Egypt and among international human rights groups.

We had a lot of discussions with His Holiness Pope Shenouda III of Alexandria and met with the minister's advisers and the president's advisers. But again, no action was taken to right the wrongs. On October 10, I, along with two other priests, was called by the criminal prosecutor for questioning. I was questioned on allegations that I coerced witnesses to change their testimonies, that I was hiding the evidence of crimes, that I was destroying the national unity of the country, and that when I preach, I preach against the government. The same five accusations were also levied against the two priests. And though the farmers reopened their case with the new attorney general, Maher Abdul-Wahed, again the inquiry was halted, with the prosecutor claiming the victims' scars were old

and no evidence linked the police to torture. Last week they finally closed the investigation of the four policemen who were accused of torturing the twelve hundred people. Not only were the police acquitted, they were each awarded one thousand Egyptian pounds for their trouble! They were not held accountable for anything. I am sorry to say that, but this is what happened.

But why should I be scared? They can't torture me because I am a religious man. My only crime is to have met all these high-ranking officials and sent memorandums to the president. I also appealed to Hafez Al Sayed Seada of the Egyptian Organization for Human Rights. And Hafez sent people from his organization to the village and they looked at the situation. They wrote a twenty-six-page report which was translated into English and sent everywhere in the world. That is all I did. Why should I be scared?

I have to defend my parishioners until the day I die. These are my children. Don't they call me father? If you went to the Coptic churches, you would see that they are filled with people. Protecting my people is part of my job. This is what I am supposed to do. If you were at your house and someone was beating up your child, wouldn't you stop them? Now if I see my children being tortured and screaming for help and I am quiet about it, I wouldn't be a good person.

KEK GALABRU

CAMBODIA

POLITICAL PARTICIPATION AND CHILDREN'S RIGHTS

"The authorities push the family to take poison,
so they die, the mother, the father, so many children, at the same time."

Born on October 4, 1942, Kek Galabru received her medical degree in France in 1968. She practiced medicine and conducted research in Phnom Penh from 1968 to 1971, and continued her work in Canada, Brazil, and Angola. In 1987– 1988 Galabru played a key role in opening negotiations between Hun Sen, president of the Cambodian Council of Ministers, and Prince Sihanouk of the opposition. That led to peace accords ending the civil war in 1991, elections held under the auspices of the United Nations. Galabru founded the Cambodian League for the Promotion and Defense of Human Rights (LICAD- HO) during the United Nations transition period. LICADHO promotes human rights, with a special emphasis on women's and children's rights, monitors vio- lations, and disseminates educational information about rights. During the 1993 elections, LICADHO's 159 staff members taught voting procedures to six- teen thousand people, trained 775 election observers, and produced and dis- tributed one million voting leaflets. Since then, LICADHO continues to monitor abuses, provide medical care, legal aid, and advocacy to victims, as well as offering direct assistance to victims of human rights violations.

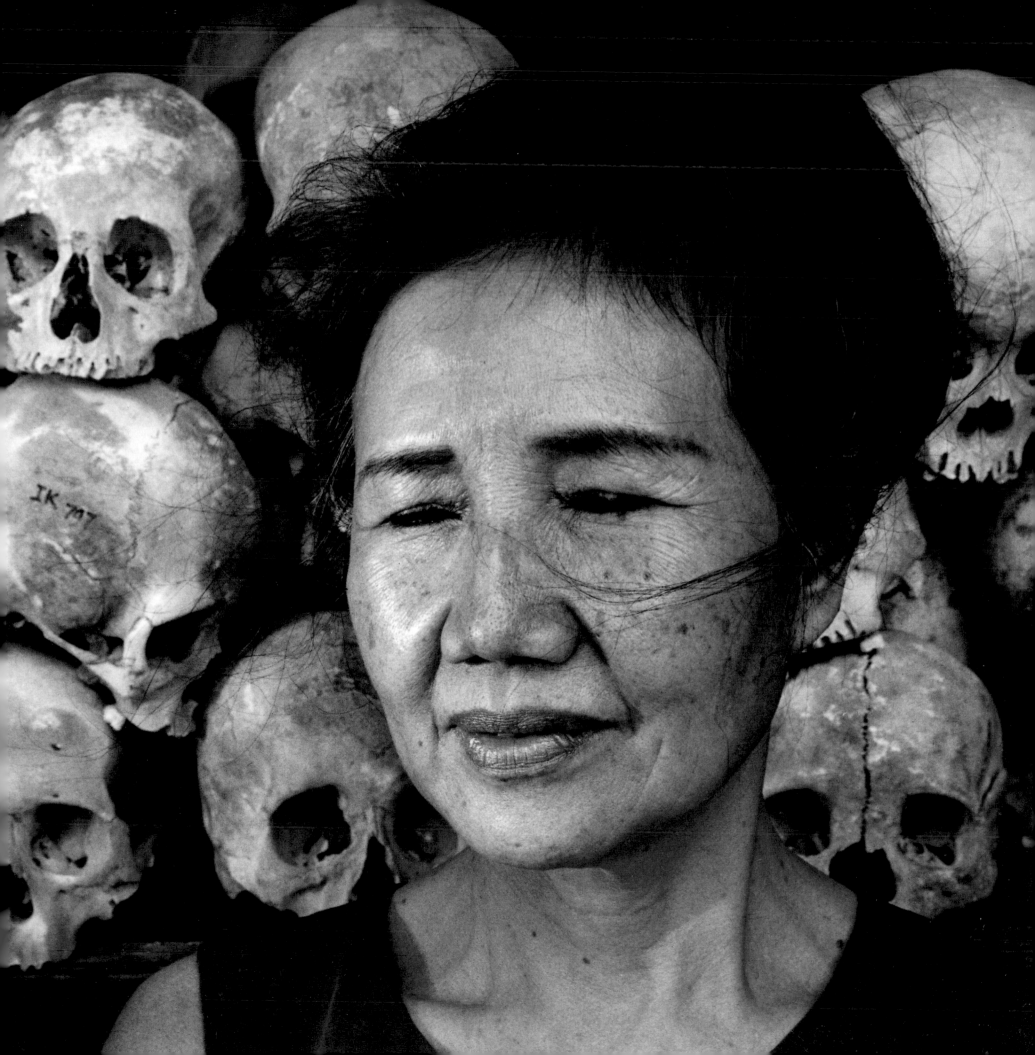

When the United Nations took over Cambodia with twenty thousand officers, we decided to start LICADHO (Cambodian League for the Promotion and Defense of Human Rights). We didn't have any money, so we opened a small office at my parents' home. Word spread quickly about this new organization, and within five or six months we had 180,000 supporters, all volunteers.

We wanted the UN to spearhead the elections and monitor the process, because that was the only way that this work could be protected. When the Royalist Party emerged in Cambodia to campaign for the 1993 election, the CPP (Cambodian People's Party and the ruling party) began to shoot the Royalist opposition in front of us. We were witnesses, and so was the UN. But the UN could do nothing because according to its mandate, they could only respond if they were attacked. For me it was unbelievable that I was going to be the watchdog of such a regime. But the purpose of LICADHO was to create an environment in which these practices would never occur again. What we saw the regime in Cambodia do was almost the same thing as the Khmer Rouge. Along with the UN, this time we documented the killings. In less than one year, hundreds of people were wounded and scores had died. Even though the ruling party could kill people, they could not stop the UN and the peace accord, and they had to permit the UN to go everywhere.

The UN set up a good network. They organized fifty thousand Cambodian volunteers for voter education. We published almost five hundred thousand booklets of the Universal Declaration of Human Rights to distribute to people, and a million one-page leaflets showing that you could vote by secret ballot. This was important because the CPP explained to people that they had a satellite that could see in the booths and tell whom you were voting for; and that if you didn't vote for them they would know. The CPP also brought people in front of Buddha and forced them to swear for whom they were going to vote, and as the CPP members were holding guns, people were afraid to vote against them. Then the CPP told them that if they don't respect their oath, Buddha would punish them with death. But we told them that Buddha is good and respects justice, that he would punish the ones violating human rights, and protect the victims. We said that when they went into the booths they would be alone to vote for whomever they liked, but we warned them not to talk afterwards. Despite the intimidation of the CPP, more than 90 percent of the people showed up to vote. And they voted for the Royalist Party, and when it won, they talked. The CPP told them to be careful, to not trust so much in the UN. They said the UN is like a boat: the boat leaves, but they are the port and they will stay here, permanently.

Now we have peace at last, but we have had a civil war since 1970 and, as a result, we have a lot of children in the street, living in bad conditions. Sometimes they are orphans, with no parents at all; sometimes they have only one parent, usually their mother. Their fathers were killed. Or their parents are too poor so the children have to try and live on their own: paint a can to sell so they can get twenty-five cents per day; sleep in the street. They are prey to foreigners who come to Cambodia for sexual tourism, pigs. Asian men in the region prefer young girls; European pedophiles prefer boys. We have many brothels and at night you will pass those brothels and find young children—eleven or twelve years old. We talked to one, only thirteen. She was already in the brothel for two years. Asian men believe that after a certain age, say fifty, if they have sexual relations with a virgin girl they become younger. By having sex with a virgin they take all the energy, all the good things from the virgin, to themselves. Now, since we have the problem of AIDS, they especially want a real virgin, because they don't wear condoms. So they send an intermediary to the village to find a very poor family and buy girls for sex. The intermediary pays the family saying, "Your daughter can work in a restaurant or clean the house of my friend: here, I know that you are very poor, here is a hundred dollars." For them a hundred dollars is a lot of money. They don't even have ten dollars at home. Then the intermediary sells the

girl to a client for between five hundred and seven hundred dollars. The man stays with the girl for one or two weeks—it's up to him, but not more than one month, because by then he's used up all the good things from the girl. After, she is sold to a brothel for two hundred dollars. Her life will be a nightmare.

One girl whose mother sold her to a brothel doesn't hate her mother. She said, "This is my karma," meaning that in her previous life she did something very bad and has to pay for the error. The girl explained, "I have to be kind with my mother because my mother is still the person who gave life to me." That girl still sends money to her mother. Government statistics say that there are twenty thousand child prostitutes in Cambodia. But we think you can multiply that number by three or four, maybe five. There are a lot but we cannot go everywhere. As it is illegal, people hide. Still, everybody knows. This is very sad and hard for us.

Child workers are another big problem. The government closes its eyes to the situation and is angry because we denounce child labor. They say, "Do you prefer children dying?" We reply, "It's good if they work, as long as it's not dangerous work." Children should go to school, but the schools are not free because of the low salary of the teachers, who get less than twenty dollars a month. You need at least two hundred dollars to live a normal life in Cambodia. And if you are sick, you borrow the money from somebody and you pay 20 percent interest per month, so people sell all their land, their house, and they become homeless. Or else the family prefers the children die. When a situation develops like this, the authorities push the family to take poison: and so the whole family dies: the mother, the father, many children at the same time. They prefer dying like that to dying from starvation. It's too hard, you know, when children are crying out, "I'm hungry, I'm hungry." We have very high infant mortality. The highest in the world, I think. A hundred and eighty children out of a thousand die before reaching five years. In your country or in Europe, maybe less than one child dies out of a thousand.

Many times with our work, we were so depressed. Sometimes we felt like asking somebody to take care of LICADHO so we could run away because it's too much for us. It could be easy for us to take our suitcases, pack, and then take an airplane and not look back. But then we said, "Impossible, they trust us." They come and work and don't take money, although they have nothing. When we need them to monitor elections, they are here. And what we do is important—during the coup and after the coup, how many people did we save? When a victim comes to see us, they say, "I know that I would have died if you were not here." That gives us more energy. If we only saved one person—it's a victory.

There are around six to nine hundred people tortured by the police in custody every year to whom we give medical assistance. Every month we help one hundred thousand to two hundred thousand people. Without us they would die. In prison, they don't have food. Just one bowl of rice and no protein, ever. Sometimes they don't even have drinking water. People ask why we help criminals in prison. But not everybody in prison is a criminal. And even if they are criminals, they at least have the right to food and medical care. One woman owed fifty dollars, so she got two years in jail. And when she got out, she still could not pay, so she went back for four years. Four years for fifty dollars. We paid for her and she got out.

It's hard sometimes. But as I told my staff, now I have energy to work with you, but please learn how to do the job, as LICADHO is yours and not mine at all. Because one day, I will need some rest. I am fifty-six years old already; some day I will have to take care of my grandchildren. They have to continue the work alone. They have a lot of courage—and for me courage means that despite the intimidation of the ruling party, you do something good for the people, for the grassroots, for your country.

ANONYMOUS

HUMAN RIGHTS

"We are helping the people. The problem is that the government doesn't want this type of help. It is certainly to the government's benefit that people don't know much about laws because then people will not demand any rights. This is one reason why it would be difficult for me to reveal my name."

Freedom House, an organization based in Washington, D.C., describes the dire state of repression in Sudan, so perilous for human rights that it is the only place in the world where we were asked not to reveal the identity of the defender: "The Sudanese government and its agents are bombing, burning, and raiding southern villages, enslaving thousands of women and children, kidnapping and forcibly converting Christian boys, sending them to the front as cannon fodder, annihilating entire villages or relocating them into concentration camps called "peace villages," and preventing food from reaching starving villages. Individual Christians, including clergy, continue to be imprisoned, flogged, tortured, assassinated, and even crucified for their faith. Sudan gained independence from Britain in 1956. Thirty years later, Islamic extremists based in Khartoum seized control of the democratically elected government, launching a holy war against their own Christian citizens in the south. This war has led to the deaths of 1.5 million people and the displacement of 5 million more. Another 2.6 million people are at imminent risk of starvation, due to the regime's scorched-earth campaign and refusal to allow access to international relief agencies. The reign of terror reaches far beyond the Christian community, to every person, animist and Muslim alike, who is suspected of failing to adhere to the government's arbitrary code of conduct. Against all odds, and under threat of certain brutal torture and death, this human rights defender we call Anonymous spreads the word of liberty, offering Sudanese compatriots a path to a better future.

I became involved in human rights because of the political situation in Sudan, when I lost my job in 1989 along with ten thousand others. The government wanted to ensure that those not affiliated with the official agenda were marginalized. I felt that we who were lucky and who had an education needed to help those with the greatest need, people who lost their basic rights and who were arrested on a nearly daily basis. We were able to extend our activities in refugee areas and around some parts of the country.

We began by raising public awareness of the negative effects of the government policy of organized mass marriages. These marriages were one of the crucial points in the political agenda. The idea was to encourage marriage to promote an image of "a good Muslim" and to discourage promiscuity and sexual dissidence. The government organizes festivals and calls people to register their names. They gather over five hundred couples at a time by bribing them with fifteen thousand Sudanese pounds and sometimes a piece of land. Given the poor state of the economy, people are encouraged to get involved in these marriages, accepting the idea that their daughter will marry a person who has married three or four times in the past, as long as it relieves them of the responsibility of having the daughter.

So these young girls marry, become pregnant, and then after collecting the money and the land, their husbands run away. In the end the women are left alone with a child to raise. They go to the *Sharia* courts in the hope of gaining maintenance fees from their husbands, but this rarely works.

Instead, as Sudan PANA (the Pan African News Agency) reported on February 1, 2000, courts in Sudan have divorced some twenty-five thousand husbands in absentia in the past three years. In such cases, the law gives the defendant a month's notice to appear before the court after a divorce advertisement is published in a newspaper. If the ultimatum expires and the husband does not comply, the court will automatically divorce the wife "in his absence."

We monitor human rights violations like these, we discuss existing laws with women's groups to raise awareness, and we network among different groups to

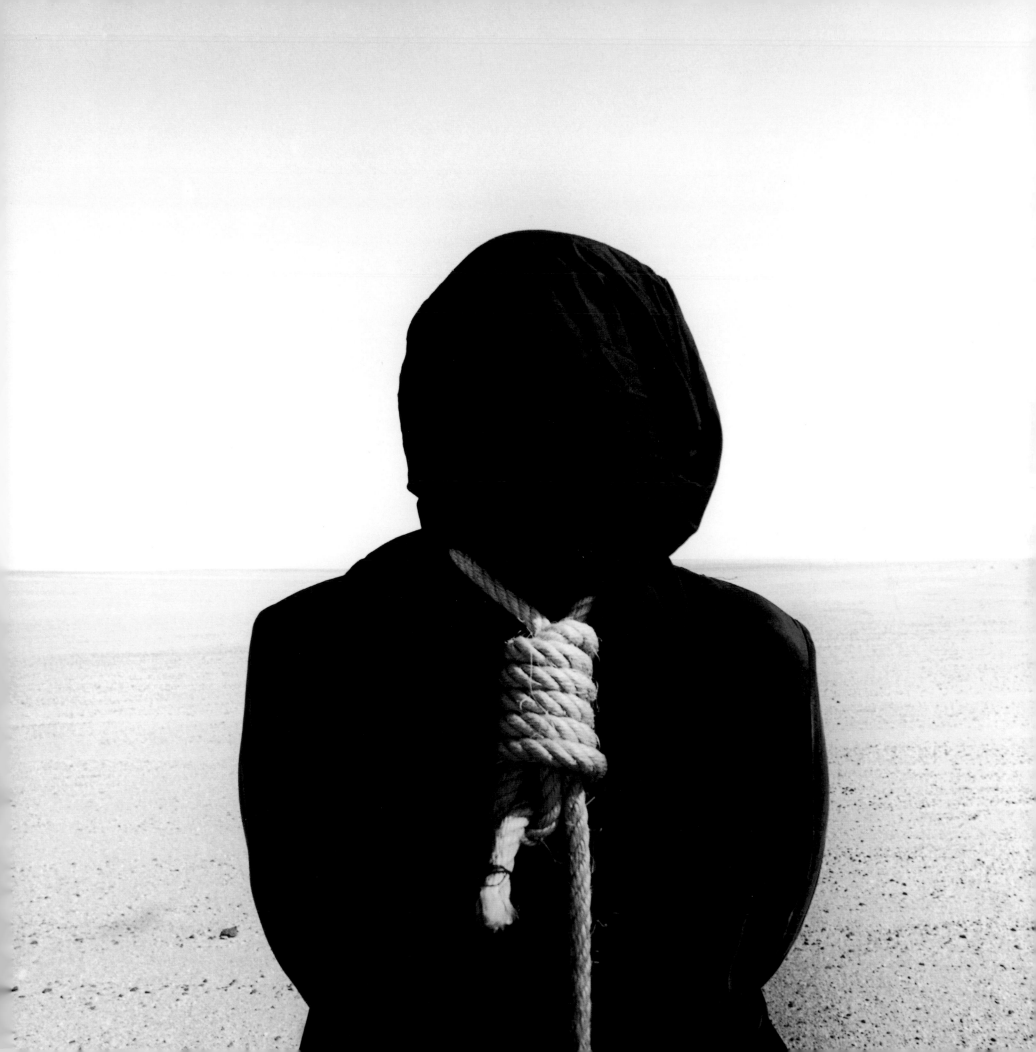

mobilize against these laws. Furthermore, we train young people to provide legal aid for the increasing number of displaced communities.

The vast majority of families in squatter communities are headed by women. The husbands are usually soldiers or unemployed men, so the women are forced to work. The easiest way to get money is to go in the streets and become a street vendor—selling tea or brewing the local alcohol, which is a traditional women's practice in the south and west. The women are, however, not aware that they are working illegally. They are subsequently arrested by the popular police force who search their houses, confiscate their belongings, and destroy their dwellings. Worse, the women can be lashed and fined £150,000 or more. One of our tasks has been to find some income-generating activities for these women. We go to courts on the behalf of the women arrested. And through networking developed with different organizations we started collecting money to pay the fines, a sum that was constantly increasing as these fines were revenue sources for the government.

We are helping the people, especially women, to become aware of their rights as human beings and as Sudanese, no matter what their ethnic group or religion is. The problem is that the government doesn't want this type of help. It is certainly to the government's benefit that people don't know much about the laws because then people will not demand any rights. This is one reason why it would be difficult for me to reveal my name. Those whom the government suspects of working on human rights are arrested, often tortured in ghost houses (which are unknown detention centers) or, if one is lucky, put in prison for an undetermined period of time. Just recently we had a journalist arrested who was kept in jail for a short while, comparatively—only two months. But he was tortured with both knees broken and his feet burned. They didn't want to release him because they were afraid that his family would object, so they kept him until his feet healed, just a week ago. There are so many incidents of the sort, as well as disappearances. People frequently disappear or are arrested, and the security people come the next day and say they died of "natural" causes. A well-known physician, the late Dr. Ali Fadl, arrested early on, in 1992, was tortured and developed a brain abscess, dying soon after. The death certificate indicated that he had cerebral malaria. His father was not allowed to take the body or even to see it, and the burial was done by security forces. This is only one of many cases.

As a consequence of the war, all young people in our country, after taking university entrance exams, are drafted and sent to *jihad*. They are given less than a month training—not nearly enough—handed weapons, and sent to the front. A group of forcibly conscribed boys escaped from a camp north of Khartoum last year. When the guards found out, they started shooting at them. The boys ran to the river but some did not know how to swim. More than fifteen were shot dead. This incident became public knowledge when the bodies floated along the Nile. Until that time the government denied it, claiming that the kids had attempted to escape, that they had gotten on a boat which had sunk, and that they had drowned as a consequence. But that was not true. They actually shot these poor boys while they were trying to swim or hide in the river.

The best way to stop these abuses is for people to be aware of their rights, especially deprived and displaced women. Over the past few years about seventeen NGOs working in women's rights have been formed. Women are forming cooperatives, developing income-generating projects, and the good thing is that these women are coming together independently of their ethnicity, religion, and race. This activity is even having an effect among Sudanese women outside the country. What is going on today seems to transcend political affiliation, and while it is slow, it is very encouraging.

Women have a particularly difficult situation in Sudan. First of all, the government issued a series of laws that restricted fundamental women's rights. Any woman who is traveling must submit her visa application to the Women's Committee at the Ministry of Interior. This committee makes sure that the woman in question has a male guardian to accompany her and that she has the consent of her husband. Second, a strict dress code dictates that every woman must cover her head and her hair completely, and wear a long dress covering her ankles. Employed women cannot hope to attain senior posts. There is a very well-known incident in the police department where two of the women reached the level of commander and were subsequently asked to resign. The government also changed family law to encourage polygamy and to give men more freedom, including making it easier for them to obtain a divorce. According to Islam, women are supposed to have access to divorce just as easily as men do. In practice, it is

extremely difficult for a woman to ask for divorce while a man can proceed with no explanations whatsoever.

Under the new family law, a man can declare *nashis* (violation of marital duties) when a woman does not obey. The husband is then allowed to place his unruly wife in an obedience home. He can refuse to divorce claiming that she, for example, goes out without his permission. This is considered sufficient justification. The government has also imposed a series of new inheritance laws that are also discriminatory to women. These new moral codes have terrible implications for society. Even if you, a woman, are just walking with a man, you have to prove that this man is your brother, or your husband, or your uncle.

Everywhere, if a woman is walking in the street without a veil, she can be arrested and lashed by the popular defense police. The same rules apply even if the women are pregnant, which is why there are so many stories of women aborting while being lashed. On buses, women have to sit in the two rows at the back. So it's been really difficult for women.

My father was a doctor. He worked in different parts of Sudan. He loved his patients. In one of the regions where he worked he was called *abu fanous,* "the man with the lantern," because he would do his rounds examining his patients in their homes, in their huts. My mother worked with different groups; Girl Guides, first aid, charity as well as church groups. Our home was always a busy home. We always had somebody who was sick coming for treatment, or giving birth in our house. My parents taught us how to love our people, however simple, however poor. We felt very much attached to them and my parents loved our family. My grandfather was a farmer and we still feel very attached to our extended family. I think my love of family made me love Sudan and regard all the Sudanese as my own family. I feel very much tied to my country. And I always had the feeling that I have to do something for my people, the same way my parents did and the way my father did for his patients. This atmosphere contributed to my taking on the work that I do today.

All over the country, the level of poverty is astonishing, especially among the displaced. Young people are willing to leave the country at any cost, so there is also a terrible brain drain happening. In some of the faculties, 70 percent of the students are girls because the boys avoid university since they are forced to go to *jihad* beforehand. Even now, there aren't any young men around, only girls, and many girls marry old men and foreigners, partly because most of the young men are away and partly because girls want to leave the country at any cost, even if it means marrying a foreigner of whom they know very little.

People are keeping quiet because they are forced to. One man who works in a bank told me that every employee in his office has two others watching him, not necessarily government agents but paid informers. Everyone is aware that the government takes advantage of the overwhelming poverty and pays people to spy on others. Youngsters are encouraged to spy on their own families and are kept on the payroll of one of the security forces. The international community could help this situation by exposing these human rights violations. What is happening could be reported through the independents such as CNN and BBC. It is not food aid for famine that is important, but media, newspapers, television coverage. That would make a difference. That would put pressure on the government, which is the cause of this deteriorating situation in human rights.

Because of this war we lost one and a half million lives and we are expecting more conflict. The south is a tragedy, but equally all the west, the north, everywhere. The country is really collapsing; the health system, education, everything. Yet at the end of the day, it is not the government who decides—it's the people. Since 1993, I have noted a new mood in the civil society. All Sudanese, and especially women, are becoming more aware of the importance of forming alliances, of trying to improve their lives, and trying to change what is going on in society. These special groups can do a lot for change. Ultimately, I don't think that the government will greatly alter in the coming five to ten years. But through this network that we are developing, and through the confidence and the hope of all human rights activists, change will come. I don't think I will witness this, but if you start moving things, there will be an effect.

Courage means a lot of things to me: it means commitment, it means hope. It means thinking first of others. It means a strong belief in human rights, a strong belief in the power of the people, and it means turning our backs on the power of the rulers. Courage will bring change to us in Sudan.

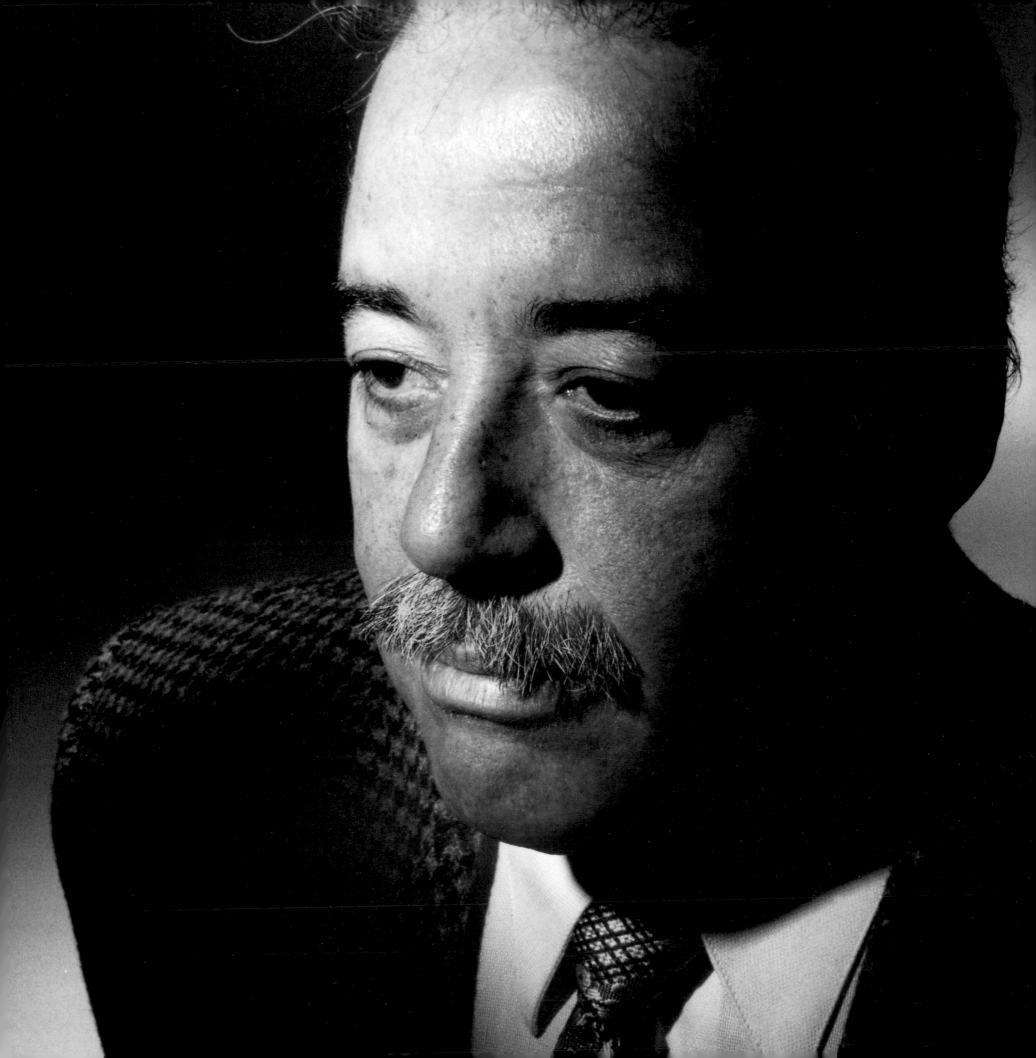

FRANCISCO SOBERÓN

HUMAN RIGHTS

"The civilian population were caught between the government countersubversive operations and the armed guerrillas. They had to live their life trying to survive in those two opposing pressures."

Dawn arrived in Peru in January 1980 and with it, a sight the world has never imagined. All over the country, dead dogs hung from lampposts announcing the first actions of Sendero Luminoso—the Shining Path, a Marxist guerrilla organization whose war against Peru's landed power oligarchy swept the country into a state of emergency from which it only now has begun to emerge. In those early days, Francisco Soberón, a young lawyer with a background in education and agricultural cooperatives, began to investigate alleged human rights violations. Taking up the cause of Peru's fragmented population caught between state security forces and the two terrorist groups, Sendero and the Tupac Amaru Revolutionary Party (MRTA), Soberón establshed Asociacion Pro Derechos Humanos (APRODEH) in 1985. The purpose of APRODEH is to combat the continued, egregious human rights abuses, including routine beatings, torture, "disappearances," and arbitrary detentions prevalent in a state where 16 percent of the country continues under complete military control to this day and all constitutional provisions are suspended. APRODEH has come to play an increasingly central role investigating and documenting human rights violations, and is known as one of the foremost human rights oganizations in Latin America. Soberón has had numerous roles, reporting to the international community, attempting to use the beleaguered judicial system, and educating the poor about their rights. In 1985, Soberón organized human rights groups from across the country into an effective coalition. He has served with numerous human rights organizations, including the United Nations, the International Federation of Human Rights (as vice president for South America), and the Coalition for an International Crime Court (as a member of the steering committee). In the violent, vicious military and political battle that has divided his country, Soberón has been viewed with suspicion and fear by both sides. Throughout the last arduous twenty years, Soberón has never failed to report abuse, even though doing so has endangered his life. Soberón could easily have sought a safer haven in his extensive travel on human rights missions throughout the world. However, he always returns to his homeland, determined to forge a new Peru, one based on human rights and democracy.

In Peru, in the early eighties, guerrilla insurgency groups like the Shining Path and MRTA started committing acts of political violence in the highlands. Initially, no one paid much attention because everyone thought it was local activity, easily defeated. But the number of incidents started to grow. After two years, the government militarized those areas, declaring emergency zones, and that's when human rights violations emerged as a pattern. At the time, I was working with organizations of peasants in rural areas. Friends of mine at the Commission on Human Rights of the Chamber of Deputies in Peru asked me to help monitor the situation. So I started researching reports from the militarized areas.

There were no nongovernmental human rights organizations in those days, except for the Catholic Church, so we started APRODEH in 1982. At the beginning there were four or five of us. We organized a legal assistance unit, a communication unit, and a documentation center. As the violence spread, our work expanded. Within the first two months, we received the first report of the enforced disappearance of seventy people in Ayacucho; within the first two years, there were nearly two thousand enforced disappearances. In 1983, there was a case of journalists ambushed and killed walking through the highlands while investigating reports of abuse. The navy controlled the area, and though there was never a conclusion to the case, the extrajudicial executions appeared to be linked to the military. We started to make reports to Amnesty International, Human Rights Watch, the International Federation of Human Rights (FIDH), and other international institutions. We didn't know we could make reports to the UN or the Inter-American Commission on Human Rights; that came later.

In the next few years, the political violence spread all over the country, the demand for monitoring the situation was enormous. As other human rights organizations were formed, we tried to join forces with them and, in 1985, established what is now the National Coordination Network of Human Rights (Coordinadora Nacional de Derechos Humanos or CNDDHH) as a network of trained human rights defenders across the country, now made up of nearly seventy organizations. With the CNDDHH we produce an annual report on the state of human rights in Peru which is distributed domestically and internationally and we do lobbying in intergovernmental bodies.

But those first efforts were very difficult because we were in a cross fire of violence. The Shining Path and MRTA were the two armed groups operating, with daily violations of humanitarian laws. And the countersubversive operations of the armed forces were responsible for human rights violations regularly, permanently: disappearances, serial executions, torture, arbitrary detentions. So we went into the emergency zones very carefully. For example, one of our colleagues from a highland department, Angel Escobar Jurado, disappeared. He talked with me by phone in the morning, telling me that he was coming to Lima, bringing information about new cases of enforced disappearances. And at 7:00 that evening, when he was leaving his office, he was detained by men believed to be army personnel. He was never seen again. This case, like thousands of others, has not been solved yet.

The human rights defenders and the civilian population were caught between the government countersubversive operations and the armed guerrillas. They had to live their life trying to survive in those two opposing pressures. That is why so many innocent people were disappeared, killed, or accused of being linked to subversive groups. Their crime was to live in an area where the armed groups operated, where they had a presence. Sometimes they were pressured to give food to them, and though it was compulsory assistance, the armed forces then considered them collaborators. During all this violence, nearly six hundred thousand people

"The executive branch of the government intervened with the judiciary and the prosecutor's office, so it was impossible to hold the military and death squads related to the military responsible, despite the mounting evidence of egregious human rights violations committed."

were displaced from the highlands to small cities in the Andes or big cities on the coast—one of the social consequence manifestations of political violence.

By the early nineties, with armed groups still present, we human rights activists started to become more visible and also more vulnerable. They were hard years and personal security was needed to protect ourselves. An activist lawyer received an enveloped bomb, was severely injured in Lima, and had to leave the country. Several of our colleagues were killed, threatened, and several were exiled. During this period we had three elected governments—and this is important, because everyone thought that in Latin America, a gross pattern of human rights violations only occurred during military regimes. But Peru has never been under a military regime during the political violence of these last decades. Nevertheless, in these seventeen years of political violence we had five thousand persons disappear, and thirty thousand people killed.

It is true that a significant percent of these crimes were perpetrated by the Shining Path. But now, after the defeat of the subversive groups, the current regime is trying to present an official history that lays all the responsibility at the feet of the subversive groups, while trying to cover up all the responsibilities of the military and the death squads related to the military forces. And that is not true.

In 1995, the present regime introduced an amnesty law to "pardon"—or rather annul—all responsibilities of the armed forces from 1980 on. Fifteen years of abuses and crimes with no possibility of investigation, punishment, or justice.

Now all of these disappeared persons were peasants, Andean people, whose main language is Quechua, not Spanish. Considered second-class citizens, there was not much attention paid to what happened to them. Not until the Shining

Path started actions in Lima did the public opinion of the urban zones realize what was really happening. In 1992, eight students and one professor disappeared from La Cantuta University in Lima, and a year later their bodies were found. Later, it was revealed that a death squad within the intelligence service of the armed forces was responsible. This was the one and only case with military personnel responsibility that was brought to justice. The perpetrators were charged, but one year later, they were given amnesty by the regime.

So in the aftermath of those years of repression, there is a lot to be done to achieve truth, justice, and reparation: all related concepts, dependent on one another. There cannot be reconciliation in Peru if we do not achieve all three for victims of political violence, and the national system of justice appears incapable to respond to these needs.

So we have turned, instead, to the Inter-American Commission. Under President Fujimori, the executive branch of the government intervened with the judiciary and the prosecutor's office, so it was impossible to hold the military and death squads related to the military responsible for human rights violations. Despite the mounting evidence of egregious human rights violations committed by this regime, it was extremely difficult to get the United Nations to respond, because the government was freely elected. The international community is tremendously resistant to intervene in a so-called democratic state. But democracy can mean many things, can't it? And here, in Peru, the true concept of democracy has not yet taken root.

The present challenge for human rights organizations is to develop an integrated conception of human rights, defending and promoting not only the civil and political rights, but also the economic, social, and cultural rights.

MARIAN WRIGHT EDELMAN

UNITED STATES

CHILDREN AND POVERTY

"Here we have poverty killing children, more slowly,
but just as surely as guns, in a nation that has been blessed with
a nine-trillion-dollar economy."

Marian Wright Edelman, founder and president of the Children's Defense Fund (CDF), the foremost children's advocacy organization in the United States, is one of the great inspirational leaders of our time. Edelman grew up in a closely knit, deeply religious family, in a small, racially segregated southern town. After graduating from Spelman College, where she joined civil rights protests, she went on to Yale Law School, and became the first black woman ever admitted to the Mississippi bar. She directed the NAACP Legal Defense and Education office in Jackson, Mississippi, where she and coworkers were regularly harassed, intimidated, and threatened for their civil rights work. In 1968, Edelman was a major force behind the Poor People's March, the last great campaign of Martin Luther King, Jr., when tens of thousands of Americans descended on Washington, D.C., demanding respect for their rights. Soon after, Edelman founded CDF, whose mission, "to leave no child behind, and to ensure every child a healthy start, a head start, a fair start, a safe start, and a moral start in life," reflects her tough-minded idealism. Under Edelman's direction, CDF provides an effective voice for poor and minority children and those with disabilities. CDF researches and disseminates information on legislation affecting the lives of children, and provides support and technical assistance to a network of state and local child advocates. A best-selling author many times over, a mother, wife, lawyer, lecturer, and a political strategist on behalf of the poor, Edelman's capacity to transform rage into courage and action has made her a central figure in the quest for justice for the dispossessed in America over the last four decades. Hers is ultimately a wake-up call, imploring us to find our soul and save our nation.

It must be hard to be a poor child in America, hard, when so many have so much, to have little and to know it. When I was growing up in the South, without television, we didn't have the sense that one had to have all these things that our consumer and excessively materialistic society tells us we need. People didn't see poverty as something that set them apart. To be poor today, to be unable to get the basic necessities of life, and then to have the judgment about who you are as a person be based on material wealth, is much more difficult. Most of our measures of success have become external.

It is absolutely obscene that we are the sole remaining superpower, number one in military expenditures, military exports, military budget, first in health technology, first in billionaires and millionaires, yet we let our children be the poorest group of Americans. We have this booming economy and budget surplus, but there are 13.5 million poor children. All the industrialized countries protect their children against preventable diseases and sickness better than we do. Over 11 million children in this country are uninsured. It's shameful that we alone among wealthy, industrialized nations don't see that our children get a healthy start. We have much higher rates of infant mortality and low-birth-weight babies than our industrialized counterparts. We lag in preparing our children in science, math, and reading compared to many of our competitor industrialized countries that they are going to be up against in the new global village. And we lag the world most shamefully in protecting our children against violence. American children fifteen and under are twelve times more likely to die from gun violence than children in twenty-five other industrialized countries combined.

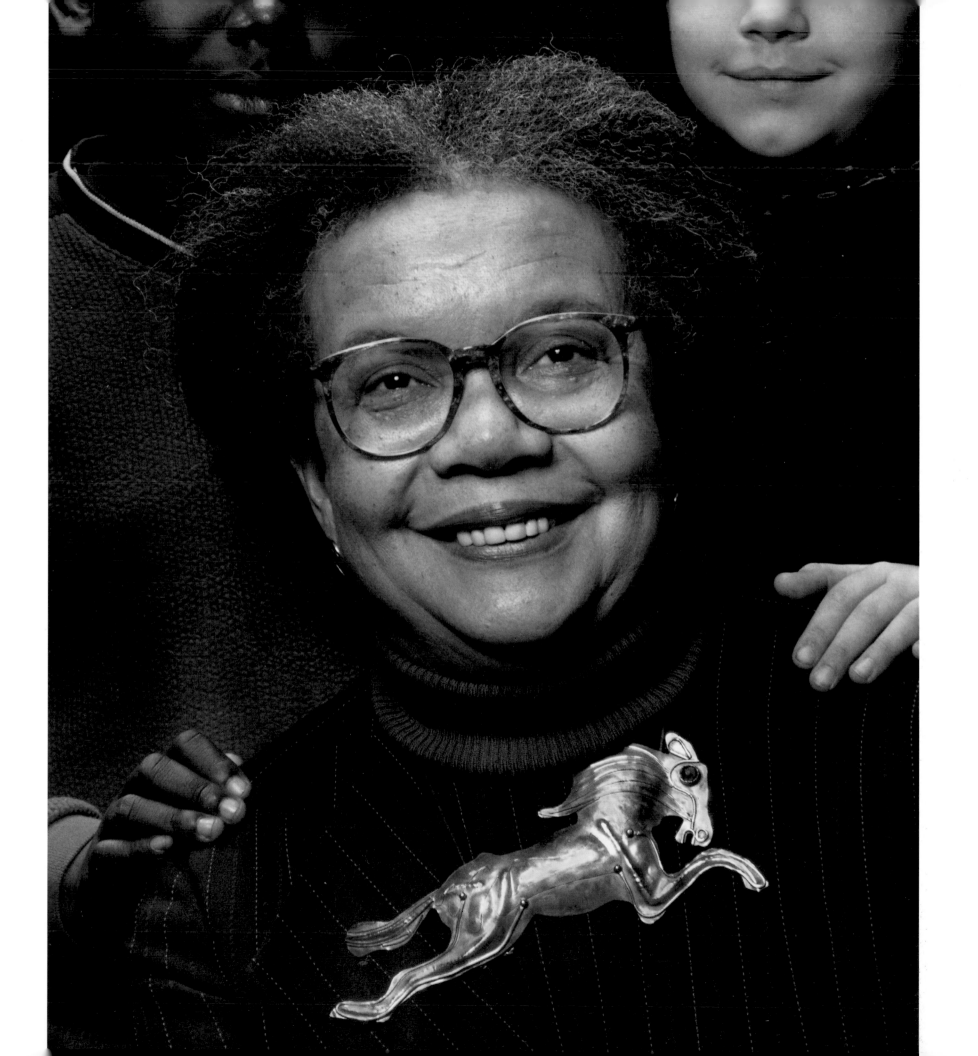

The fact that we spend more of our resources on military expenditures is not disconnected from the obsession we have with, and the glorification of, violence in our culture. On the cusp of a new era, we have some very fundamental decisions to make about who we are. We calculated how many Americans have killed themselves or other people in our own nation between 1968 and 1997. The total is 1.4 million. That is more than all the American battle casualties in all the wars in which we participated in this century. Between 1979 and 1997, nearly 80,000 children were killed by guns, far more than we lost in battle casualties in Vietnam. If you look at the over 200 million guns in circulation and how easily accessible they are to children and criminals, it's amazing to me that Littleton, Colorados don't happen more often. My recollection of that figure is that about 920,000 people have been killed by guns. And if you look at the 400,000 plus gun suicides done in this period, 92 percent of those were white, and of the homicides, about half were black and half were white. But this slaughter, the presence of guns, and the worship and tolerance of violence as power is something we are going to have to confront.

Here we are on the cusp of a new millennium. God has blessed us with more riches than we know what to do with, yet we let millions of our children go hungry, without shelter, and without other basic necessities of life. Here we are blessed with the best health technology, yet we have places where children's immunization rates fall behind those of some developing nations, and eleven million children are without health coverage. The Children's Defense Fund mounted a campaign in New York City where the preschool immunization rate has risen from 52 percent to 80 percent. We are trying to get it to 90. As a nation, we've got the means to prevent child gun deaths and to end child poverty and preventable diseases, but we haven't got the will. Here we have poverty killing children, more slowly, but just as surely as guns, in a nation that has been blessed with a nine-trillion-dollar economy. So I hope that we will find a way to redefine what we view as progress. There is much to do. We addict our children to consumption and tell them you have to have the latest material things in order to be viewed as somebody, yet we don't provide the education and training for them to get the jobs to get those things legally. We've also told rich kids that they need all those things, and they're finding that their appetites aren't really satisfied. So we have a spiritual poverty problem that is going to have to be confronted in a culture that treats children as consumers rather than as developing human beings in need of protection. That is probably the central issue we have to work on.

We lose a classroom full of children every two days. A quiet Littleton almost every day, in which nearly twelve children are killed by gunfire. But you know, it's dispersed and many of them aren't white so nobody pays attention. The attention to Littleton reminds one of the project in 1964 when middle-class white youths came to Mississippi to help black adults register to vote. The nation was shocked when two white youths were killed along with one black youth and they were exposed to the dangers which blacks faced. It was a wake-up call. A bunch of white youths were shot at school in a suburb in

"We lose a classroom full of children every two days. A quiet Littleton almost every day, in which nearly twelve children are killed by gunfire. But you know, it's dispersed and many of them aren't white so nobody pays attention."

Colorado, where most of the violence does not occur. Most of the violence occurs at home, and in the streets, and is perpetrated by people who know each other. To be talking about the President's proposal for a $1.5 trillion increase in this post—Cold War era to protect children against outside enemies, when they are being killed like fleas here at home, while they struggle to read and get ready for school, is obscene. Nothing short of a powerful movement is going to work and help change these wrongheaded priorities.

Well, the military has been very smart. They spread their bases and weapons production in every state, like the B-2 bomber, where they put a piece of construction in almost every congressional district. And so it's all about political fat and jobs in the local district and they're having a very hard time closing the bases. Everybody has their own favorite weapon systems. And so it is extremely difficult to change fundamental priorities. We certainly know how to give good prenatal care, and immunize children, and prevent child neglect, and provide them with health insurance. But we will succeed in protecting children only if there is a strong counterforce.

Race plays a big role in lots of complicated ways. It has been the tradition for powerful southerners to use race as a way of dividing the poor white and black citizens. Even though there are more poor white children and families who are struggling, more poor whites who are hungry, and more poor whites without health insurance, in their own minds, they have had poverty defined as something that is about "those other people"—black people and brown people. Many powerful, wealthy interests, whether they are big farmers or political operators, sought to maintain

control and power by keeping folks divided, and making poor whites feel that somehow they were much better because of that white skin. And so there was always an economic underpinning to racism that in many ways continues, and that is very sad. The issues of children, race, and poverty are intertwined.

One of the messages that we have to set forth is that most poor people today are working. Seventy percent of poor children live in a working family that is struggling to make ends meet. So if we really don't believe in welfare, why don't we make sure there is health care and child care and transportation available for working families. And we'll see what kind of debate we have, particularly in this era of budget surplus, about why many states are not really rushing to prepare people for work. That's going to be a real challenge. But the racial issue, and the fact that most poor people are white and work, is a hard one in the media and every place else. We have made a conscious effort over the last twenty-five years to try to redefine the face of the poor and hurting child. Black and brown children have a disproportionate chance of being poor and being at risk of all the worst things. Still, in numbers, there are more poor whites. We constantly try to say that the majority of children who are affected are white, and we always try to get white welfare recipients to testify so that the congresspeople realize this can happen to somebody they identify with. But there is such a long history of stereotyping that is constantly reinforced by the media, it is very difficult not to have people constantly put a black face on poverty. Being black, being black male and black female, makes it much harder to beat the odds. Ninety percent of our poor, brown, black, disabled, and

immigrant children are in public schools and so many people really don't think they can learn. They think it's pouring good money into bad vessels. And there are few school systems in America where all children are expected to learn and are supported in learning. As a result, the children who need the most get the least. They get the poorest schools, the poorest teachers, the poorest labs, the poorest books, and that's racism. And racism imprisons them in neighborhoods that have been red-lined. You see the same thing in the misapplication of the criminal justice system. And so if you go from a black and poor child's life in the beginning, they begin with two strikes against them. Although we have made great progress, it is still harder to be both poor and black. And if you look at life expectancy, or poverty, or violence, blacks are disproportionately victimized. We once did a sheet showing if you are a black male in America, you are far more likely to be killed than people in many other countries. We couldn't get it all on one page. We just folded it out to compare it with violence and death rates in other countries. So race is still a real problem. Black parents who have had black sons understand that their skin is the magnet for racial profiling, police assaults, and for just walking down the street. We know we have not solved the problem of race in America.

I was blessed to have been challenged to do something that's worth living and dying for, and to have a life that's never lacked purpose. And I have been blessed with extraordinary role models throughout, starting with my parents. There is a lot of discussion about mentoring. I had the great women of Mississippi as my mentors. I was a lawyer by the time I went back to Mississippi. One case I worked on involved an immensely courageous black woman, Mrs. Mae Bertha Carter, the first school desegregation plaintiff in Sunflower County. She wanted her eight younger children not to have to go into the cotton fields like her older kids. She described what it felt like the first day the white school bus came and she saw those kids go off to the formerly white school and how every afternoon she'd wait and count them all as they came in. She said they would share the horrors that would go on during the day, and she would just pray all the time. They got evicted, they got shot at, they had no credit. And we finally used her case to throw out freedom of choice in Mississippi. When I hear educational choice today, I remember so-called freedom of choice in earlier days. I have such a strong commitment to a strong public school education for every child. I never feel I am half as good as those incredible, ordinary people who, day in and day out, withstood beatings, assaults, and torments without bitterness and with a transcendent faith. I don't think I got a child out of jail who hadn't been beaten or worse. Extraordinary daily courage by extraordinary people who had grit made me feel I had a pretty easy life.

The first time I walked into a federal court in Mississippi, there were all these white male lawyers sitting around a table, and not a single one would speak or shake hands. I knew who I was and I had a job to do, but there were times when I was absolutely terrified. I happened to have been in Mississippi the first day that police dogs were brought out against civil rights demonstrators. I was trying

"I am also clear that if we do not save our children, we are not going to be able to save ourselves. I cannot believe that God gave us all of these riches, and we would fail to take care of the most vulnerable among us."

hard not to get arrested because I knew my ability to get into the Mississippi bar was at stake. I watched in terror and awe as Bob Moses and Jim Forman and others including old people were attacked and scattered by these dogs. But Bob didn't move. To watch their courage on a daily basis just gives you enough to talk about to yourself and to think, "What are you complaining about?"

I am also clear that if we do not save our children, we are not going to be able to save ourselves. I cannot believe that God gave us all of these riches, and we would fail to take care of the most vulnerable among us. Taylor Branch said that never before in history have school children been the decisive factor in the transformation of a nation. We often forget that it was children who had to go through the mobs and weather the violence in Birmingham and Selma; children who were herded into the cattle cars and jails in Jackson. Their parents were terrified, but their children were the frontline soldiers. Look at the sacrifices of those four girls blown asunder in Birmingham. I was blessed by the opportunity that Dr. King and the Movement provided to feel empowered as a young person, and by how absolutely ready and prepared we were to die and to do whatever was necessary.

Commitment is both a gift of God and the luck of circumstance. I grew up in a family that really did believe in the graciousness of God. Mrs. Mae Bertha Carter said it very eloquently when she said, "God has a good purpose for all of us. And so God builds in those strengths to do what you have to do." And I think she was echoing Kierkegaard who said that everybody needs to open up the envelope of their soul and get their orders from inside of you. And nobody ever said that it was going to be easy. But you have to try.

Courage is just hanging in there when you get scared to death. One of the things that I remember about Dr. King is how as a young person he could always look scared to death. Look at his face in many of his pictures, he is depressed. He often did not know what he was going to do next. I remember him saying how terrified he was of the police dogs in the back of the car when he was being taken out to rural Georgia after being arrested. And in my little college diary, the first time I met him, I must have written down half of the speech he gave, about how you don't have to see the whole stairway to take the first step. You can be scared but shouldn't let it paralyze you. And he used to say over and over again, "If you can't run, walk; if you can't walk, crawl, if you can't crawl, just keep moving." That reflects courage. There comes a point in life when you look around and decide that this is not what life's about. It is not what God meant for you. And you have to change things. And if that means dying, that's fine. But it is not living. Otis Moss used an analogy recently that the worst thing to happen to a bird is not to kill it, it's to clip its wings, to clip it's tongue. Many people were terrified in the civil rights days but terror is a part of living in an unjust system. I felt that when I went to Crossroads, the Cape Town camp out in South Africa. When I saw those young people, I saw myself thirty years earlier, and I knew they would just not stop. That's courage—acting despite it all.

DIGNA OCHOA

MEXICO

HUMAN RIGHTS

"Anger is energy, it's a force. If an act of injustice doesn't provoke anger in me, it could be seen as indifference, passivity. It's injustice that motivates us to do something, to take risks, knowing that if we don't, things will remain the same."

One of the foremost human rights attorneys in Mexico, Digna Ochoa is also a nun. As defense attorney at PRODH (Centro de Derechos Humanos Miguel Agustín Pro Juárez, known as Centro Pro, or "the Pro"), Ochoa has taken on some of Mexico's most politically charged cases, including the defense of alleged members of the Zapatista insurgency in Chiapas. She has won acquittals in several highly publicized cases. In many cases, Ochoa's clients were subjected to torture and due process violations. Ochoa herself has been threatened with death, abducted, and subjected to extensive harassment. Just a few weeks after this interview, two men assaulted her in her own apartment. They blindfolded her, tied her up, interrogated her, threatened her, and pressured her to sign a statement. They cut her phone line, and opened a gas valve in a closed room. Miraculously, she survived. Her attackers left files stolen during an attack a few months earlier, while the next day PRODH staff found their offices had been broken into and ransacked. Nevertheless, Ochoa went right back to work at the Pro. In recent years human rights advocates, government investigators, and opposition leaders have been murdered in Mexico. The Inter-American Court of Human Rights has required the Mexican government to take steps to assure the safety of PRODH staff in the wake of this pattern of persecution against the organization. Meanwhile, Digna Ochoa fights on.

DIGNA OCHOA

I am a nun, who started life as a lawyer. I sought a religious community with a social commitment, and the protection of human rights is one of the things that my particular community focuses on. They have permitted me to work with an organization that fights for human rights, called Centro Pro, supporting me economically, morally, and spiritually. This has been a process of building a life project, from a social commitment to a spiritual one with a mystical aspect.

My father was a union leader in Veracruz, Mexico. In the sugar factory where he worked, he was involved in the struggles for potable water, roads, and securing land certificates. I studied law because I was always hearing that my father and his friends needed more lawyers. And all the lawyers charged so much. My father was unjustly jailed for one year and fifteen days. He was then disappeared and tortured—the charges against him were fabricated. This led to my determination to do something for those suffering injustice, because I saw it in the flesh with my father.

When I first studied law, I intended to begin practicing in the attorney general's office, then become a judge, then a magistrate. I thought someone from those positions could help people. After I got my degree, I became a prosecutor. I remember a very clear issue of injustice. My boss, who was responsible for all of the prosecutions within the attorney general's office, wanted me to charge someone whom I knew to be innocent. There was no evidence, but my boss tried to make me prosecute him. I refused, and he prosecuted the case himself.

Up until that time, I was doing well. The job was considered a good one, because it was in a coffee-producing area and the people there had lots of money. But I realized that I was doing the same thing that everyone did, serving a system that I myself criticized and against which I had wanted to fight. I decided to quit and with several other lawyers opened an office. I had no litigation experience whatsoever. But I was energized by leaving the attorney general's office and being on the other side, the side of the defense.

The first case I worked on was against judicial police officers who had been involved in the illegal detention and torture of several peasants. We wanted to feel like lawyers, so we threw ourselves into it. Our mistake was to take on the case without any institutional support. I had managed to obtain substantial evidence against the police, so they started to harass me incessantly, until I was detained. First, they sent telephone messages telling me to drop the case. Then by mail came threats that if I didn't drop it I would die, or members of my family would be killed. I kept working and we even publicly reported what was happening. The intimidation made me so angry that I was motivated to work even harder. I was frightened, too, but felt I couldn't show it. I always had to appear—at least publicly—like I was sure of myself, fearless. If I showed fear they would know how to dominate me. It was a defense mechanism.

Then, I was disappeared and held incommunicado for eight days by the police. They wanted me to give them all the evidence against them. I had hidden the case file well, not in my office, not in my house, and not where the victims lived, because I was afraid that the police would steal it. Now, I felt in the flesh what my father had felt, what other people had suffered. The police told me that they were holding members of my family, and named them. The worst was when

> "I've always felt anger at the suffering of others. For me, anger is energy, it's a force."

they said they were holding my father. I knew what my father had suffered, and I didn't want him to relive that. The strongest torture is psychological. Though they also gave me electric shocks and put mineral water up my nose, nothing compared to the psychological torture.

There was a month of torture. I managed to escape from where they were holding me. I hid for a month after that, unable to communicate with my family. It was a month of anguish and torture, of not knowing what to do. I was afraid of everything.

I eventually got in touch with my family. Students at the university, with whom I had always gotten along very well, had mobilized on my behalf. After I "appeared" with the help of my family and human rights groups in Jalapa, Veracruz, I was supported by lawyers, most of whom were women. The fact that I was in Veracruz caused my family anguish. At first I wanted to stay, because I knew we could find the police who detained me. We filed a criminal complaint. We asked for the police registries. I could clearly identify some of the officers. But there was a lot of pressure about what I should do: continue or not with the case? My life was at risk, and so were the lives of members of my family. After a month of anguish, my family, principally my sisters, asked me to leave Jalapa for a while. For me, but also for my parents.

I came to Mexico City. The idea was to take a three-month human rights course for which I had received a scholarship. I met someone at the human rights course who worked at Centro Pro, one of the human rights groups involved on my behalf. One day he said, "Look, we're just setting up the center and we need a lawyer. Work with us." I had never dreamed of living in Mexico City, and I didn't want to. But I accepted, because the conditions in Jalapa were such that I couldn't go back. Two really good women lawyers in Jalapa with a lot of organizational support took up the defense case I had been working on. This comforted me, because I knew the case would not be dropped—I had learned the importance of having organizational backup. So I started to work with Centro Pro in December 1988. Since I began working with the organization, I've handled a lot of cases of people like my father and people like me. That generates anger, and that anger becomes the strength to try to do something about the problem. At work, even though I give the appearance of seriousness and resolve, I'm trembling inside. Sometimes I want to cry, but I know that I can't, because that makes me vulnerable, disarms me.

At this time, because of what happened to me, I needed the help of a psychoanalyst, but I wasn't ready to accept it. The director of Centro Pro prepared me to accept that support. He was a Jesuit and psychologist. For six months, I didn't know he was a therapist. When I found out, I asked him why he hadn't told me. "You never asked," he said. We became very close. He was my friend, my confessor, my boss, and my psychologist, too, although I also had my psychoanalyst.

The idea of a confessor came slowly to me. In Jalapa, I had been supported by some priests. When I first "appeared," the first place I was taken was a church. I felt secure there, though as a kid, I had never had much to do with priests, besides attending church. To me they were people who accepted donations,

delivered sacraments, and were power brokers. It made an impression on me to see priests committed to social organizations, supporting people.

Since I've been at Centro Pro, we've gone through some tough times, like the two years of threats we received beginning in 1995. Once again it was me who was being threatened. My first reaction was to feel cold shivers. I went to the kitchen with a faxed copy of the threat and said to one of the sisters in the congregation, "Luz, we've received a threat, and they're directed at me, too." And Luz responded, "Digna, this is not a death threat. This is a threat of resurrection." That gave me great sustenance. Later that day another of my lawyer colleagues, Pilar, called me to ask what security measures I was taking. She was—rightfully—worried. I told her what Luz had said and Pilar responded, "Digna, the difference is that you're a religious person." And I realized that being a person of faith and having a community, that having a base in faith, is a source of support that others don't have.

Now, some people said to me that my reaction was courageous. But I've always felt anger at the suffering of others. For me, anger is energy, it's a force. You channel energy positively or negatively. Being sensitive to situations of injustice and the necessity of confronting difficult situations like those we see every day, we have to get angry to provoke energy and react. If an act of injustice doesn't provoke anger in me, it could be seen as indifference, passivity. It's injustice that motivates us to do something, to take risks, knowing that if we don't, things will remain the same. Anger has made us confront police and soldiers. Something that I discovered is that the police and soldiers are used to their superiors shouting at them, and they're used to being mistreated. So when they run into a woman, otherwise insignificant to them, who demands things of them and shouts at them in an authoritarian way, they are paralyzed. And we get results. I consider myself an aggressive person, and it has been dif-

ficult for me to manage that within the context of my religious education. But it does disarm authorities. I normally dress this way, in a way that my friends call monklike. That's fine. It keeps people off guard. I give a certain mild image, but then I can, more efficiently, demand things, shout.

For example, one time there was a guy who had been disappeared for twenty days. We knew he was in the military hospital, and we filed habeas corpus petitions on his behalf. But the authorities simply denied having him in custody. One night we were informed that he was being held at a particular state hospital. We went the next day. They denied us access. I spent the whole morning studying the comings and goings at the hospital to see how I could get in. During a change in shifts, I slipped by the guards. When I got to the room where this person was, the nurse at the door told me I could not go in. "We are not even allowed in," she said. I told her that I would take care of myself; all I asked of her was that she take note of what I was going to do and that if they did something to me, she should call a certain number. I gave her my card. I took a deep breath, opened the door violently and yelled at the federal judicial police officers inside. I told them they had to leave, immediately, because I was the person's lawyer and needed to speak with him. They didn't know how to react, so they left. I had two minutes, but it was enough to explain who I was, that I had been in touch with his wife, and to get him to sign a paper proving he was in the hospital. He signed. By then the police came back, with the fierceness that usually characterizes their behavior. Their first reaction was to try to grab me. They didn't expect me to assume an attack position—the only karate position I know, from movies, I suppose. Of course, I don't *really* know karate, but they definitely thought I was going to attack. Trembling inside, I said sternly that if they laid a hand on me they'd see what would happen. And they drew back, saying, "You're threatening us." And I replied, "Take it any way you want."

"If we don't forgive and get over the desire for revenge, we become one of them. You can't forget torture, but you have to learn to assimilate it. To assimilate it you need to find forgiveness. It's a long-term, difficult, and very necessary undertaking."

After some discussion, I left, surrounded by fifteen police officers. Meanwhile I had managed to record some interesting conversations. They referred to "the guy who was incommunicado," a term that was very important. I took the tape out and hid the cassette where I could. The police called for hospital security to come, using the argument that it wasn't permitted to have tape recorders inside the hospital. I handed over the recorder. Then they let me go. I was afraid that they would kidnap me outside the hospital. I was alone. I took several taxis, getting out, changing, taking another, because I didn't know if they were following me. When I arrived at Centro Pro, I could finally breathe. I could share all of my fear. If the police knew that I was terrified when they were surrounding me, they would have been able to do anything to me.

Sometimes, without planning and without being conscious of it, there is a kind of group therapy among the colleagues at Centro Pro. We show what we really feel, our fear. We cry. There's a group of us who have suffered physically. On the other hand, my religious community has helped me manage my fear. At times of great danger, group prayer and study of the Bible and religious texts helps me. Praying is very important. Faith in God. That has been a great source of strength. And I'm not alone anymore. As a Christian, as a religious person, I call myself a follower of Christ who died on the cross for denouncing the injustices of his time. And if He had to suffer what he suffered, what then can we expect?

For years after my father was tortured, I wanted revenge. Then, when I was the torture victim, the truth is that the last thing I wanted was revenge, because I feared that it would be an unending revenge. I saw it as a chain. Three years after coming to Mexico City I remember that a person came to tell me that they had found two of the judicial police officers who tortured me.

The person asked if I wanted him to get them and give them their due. At first, I did have a moment when I thought yes. But I thought about it and realized that I would simply be doing what they did. I would have no right to speak about them as I am talking about them now. I would have been one of them.

I rarely share my own experience of torture. But I remember talking to a torture victim who was very, very angry, for whom the desire for revenge was becoming destructive. I shared my own experience, and that made an impression on him. But if we don't forgive and get over the desire for revenge, we become one of them. You can't forget torture, but you have to learn to assimilate it. To assimilate it you need to find forgiveness. It's a long-term, difficult, and very necessary undertaking.

If you don't step up to those challenges, what are you doing? What meaning does your life have? It is survival. When I began to work, when I took that case in which they made me leave Jalapa, I was committed to doing something against injustice. But there was something else that motivated me, and I have to recognize it, even though it causes me shame. What motivated me as well as the commitment was the desire to win prestige as a lawyer. Thanks to the very difficult situation that I lived through, I realized what was wrong. What a shame that I had to go through that in order to discover my real commitment, the meaning of my life, the reason I'm here. In this sense, I've found something positive in what was a very painful experience. If I hadn't suffered, I wouldn't have been able to discover injustice in such depth. Maybe I wouldn't be working in Centro Pro. Maybe I wouldn't have entered the congregation. Maybe I wouldn't have learned that the world is a lot bigger than the very small world that I had constructed. Thanks to a very difficult, painful experience for me and my family and my friends, my horizons were broadened. Sometimes I say to myself, "What a way for God to make you see things." But sometimes without that we aren't capable of seeing.

GUILLAUME NGEFA ATONDOKO

DEMOCRATIC REPUBLIC OF THE CONGO

POLITICAL RIGHTS

"We knew exactly how many people were killed. And we passed on the information. Then the government began to take notice."

Researching, recording, and exposing grave human rights abuses committed by Zaire's notorious dictator, Mobutu Sese Seko, Guillaume Ngefa risked his life on a daily basis. As founder and president of his country's premier human rights organization, L'Association Africaine de Défense des Droits de l'Homme (African Association for the Defense of Human Rights, or ASADHO), Ngefa monitored the bloody seizure of power by President Laurent Kabila in 1996–97 during which, Ngefa estimates, "200,000 refugees in Zaire, mostly ethnic Hutus, and thousands of Zairians were killed as a result of the deliberate strategy of extermination of a portion of the Rwandan population." Ngefa based his report on field research, along with a synthesis of reports by a number of human rights and humanitarian organizations. Persecuted first by Mobutu and then by Kabila, Ngefa and ASADHO gained a reputation for even-handed and well-documented reports of abuses, regardless of the ethnic affiliation of perpetrators or victims. As such, ASADHO is a pillar of moral and ethical support for Congolese working to reduce interregional and interethnic tensions. As a result of his unflinching honesty, Ngefa is now living in exile in Geneva, Switzerland, where he continues to work for human rights and for the dignity of his countrymen.

GUILLAUME NGEFA ATONDOKO

Human rights are rooted in my life. I'm told that as a child I reached out to others. I befriended pygmies, even though, in my community, they were considered to be animals. I cut bread with them, I brought them to our home, I gave them my clothes. It was a shock to the society around me but I saw the pygmies as my friends, just like anyone else.

While I was training as a Jesuit, one of my professors spoke about human rights. Later, I decided to leave the order and went to the University of Kinshasa. I was horrified by the ethnic hatred among students and the police informers planted in the university, so I became part of a network collecting information about the repression of the regime. I began to send this information to embassies in Kinshasa, listing who had been killed within one or another university. In 1986, I founded an organization called Club des Africanistes, a group where students interested in African matters could discuss their ideas. We organized a big meeting in Kinshasa, where students from all universities and institutions could discuss the issue of *francophonie* (French as a common language). Trying to organize this kind of meeting under one ruling party was dangerous, and I was soon charged with receiving money from foreign governments to destroy the regime. The dean warned me that if I continued with the "subversive activities" I would be expelled from the university.

When I returned to school, I created an organization to fight against ethnic divisiveness among students. When our numbers swelled to include over six hun-

dred members, we decided to run for student elections against the ruling party. We refused to endorse Mobutu and his old political cronies. The academic authorities accused us of being backed by foreign countries. Though we lost the student election, our message was heard within our university, and we were respected. Then the president of the university called us to say that our movement was becoming very political and would be banned. He threatened me with expulsion for the second time. I had one year left until graduation and so I tried to negotiate. We said, "We will not accept this ban. We will continue our movement because we think that our movement is not against the regime but is against some of these ideas which will affect the university in a very dangerous way." He accepted our compromise.

I graduated just when the general discontent with Mobutu began to open the political system. The time was right to start a human rights organization and participate in public affairs. First I recruited activists from our two university organizations. Our founders were old friends. We knew each other and trusted one another. We called ourselves ASADHO, and set out to investigate and document human rights abuses, to play a key role in society, to maintain independence from all political parties, and to hold onto our principles. The organization was national, drawing together people from different regions. We began working with lawyers, journalists, and physicians. Each group tried to strengthen or promote human rights by using their par-

"The cops came, pointed their guns in my direction, and forced me into a car. They brought me to the Camp Tshatshi [home of presidential elite troops] and began punching people in my presence. One guy said, 'After him, it will be you.'"

ticular expertise. For example, our physicians gave us information about human rights violations suffered by victims of AIDS. Some people who had served as human guinea pigs had been injected with the AIDS virus, without their knowledge, in the name of "scientific research." We relayed that information to the outside world, to human rights groups and to the press. We published reports at the same time. We knew exactly how many people were killed. And we passed on the information.

Then the government began to take notice. I was arrested and beaten up many times in 1993 and 1995 and have had problems with hearing in the left ear ever since. Nobody would rent me an apartment because they were afraid that the security forces would destroy their house. Once when I was walking on the street the cops came, pointed their guns in my direction, and forced me into a car. They brought me to the Camp Tshatshi [home of presidential elite troops] and began punching people in my presence. One guy said, "After him, it will be you." I got nervous. I said, "Look, the American authorities know that I am here." After they beat me, they let me go.

In August 1995 I had dinner with the Swiss ambassador, the chargé d'affaires of Belgium, and some of my colleagues. That same day, I had published a report denouncing the elite troops' killing of thirteen members of the PALU (Parti Lumumbiste Unifié) party. As I was driving home after dinner, I was stopped by

soldiers shouting, "Get out! Get out! Get out! Get out!" One put a gun to my head. They told me they would kill me. People recognized me and tried to help. The soldiers shot into the air and people fled, but the soldiers were afraid, too, and said, "Get into your car and go." As I was driving away, I thought they would shoot me in the back. When I got home my wife was waiting for me. I told her the story. "It was you?" she asked. She had heard the shooting. I realized that it was time to leave the country.

After obtaining a master's degree abroad, I returned from exile, continued my work, and told Mobutu that I wanted to change things. However, in 1997, during the rebellion led by Kabila against Mobutu, ASADHO disclosed a report denouncing the slaughter and extermination of Hutu refugees by Rwandese troops at the command of Kabila. In this context, I was threatened not only by Mobutu's troops, but also by Kabila's, who claimed that I was opposing the war of liberation, and promised to "tear me to pieces" if they found me. This is what made me decide to leave my homeland for good.

I didn't get a chance to become a priest, but with human rights I found a new vocation. It's the same: trying to create a voice for the voiceless. I'm against injustice; I will never stop. Courage is conviction, courage is your commitment to something. You just have to believe in what you are doing, that's all.

WEI JINGSHENG

CHINA

————

POLITICAL PARTICIPATION AND IMPRISONMENT

"If you do not fight tyranny, the tyrants will never let
you have an ordinary life. You must either surrender to them,
or dedicate your life to something greater."

Wei Jingsheng came to symbolize the struggle for human rights and democracy in China, when, after the Cultural Revolution, he was among the first to demand a freer society. In spite of the threat of imprisonment, Wei spoke openly with the Western press, publishing articles demanding reform and comparing the policies of all-powerful Premier Deng with the disastrous Five-Year Plans of Chairman Mao. For his candor he was sentenced to fifteen years in the infamous Chinese laogai (prison labor camps), mostly in solitary confinement where he suffered serious abuse. Though Wei's health deteriorated, his determination grew ever stronger. On September 14, 1993, days before the International Olympic Committee's vote on whether China could host the games, Wei was released. Authorities hoped he had learned his lesson, but instead Wei contacted reformers who had been virtually silent since Tiananmen and was pivotal in reviving the democracy movement in China. After his meeting in 1994 with U.S. Assistant Secretary of State for Human Rights John Shattuck, the Chinese government lashed out, once again detaining Wei and holding him incommunicado for more than a year. The regime then subjected their most visible prisoner to a show trial and sentenced him to a second fourteen years in the laogai. In 1997 intense international pressure caused Wei to be sent into exile instead. Now based at New York's Columbia University, he travels the world, speaking out forcefully against China's continuing abuses of the human rights of its own people.

Living in jail and living in exile are both difficult. But from outside I can be much more help to the democracy movement than when I was shut in.

In exile, my health is cared for; I eat much better. But there are certain things that are much better in prison. For one thing, in prison, few people could disturb my peace of mind. I didn't have to listen to as much nonsense inside the prison as out here. In prison one's enemies are clear, and you try to make friends with your enemy, and soon one can win faithful friends from among one's captors. Outside, in exile, the conditions are exactly the opposite. There are many claiming and clamoring to be friends, but who are actually enemies, who will do things to harm you, and to harm the movement. This can get very complicated.

Some of the nonsense comes from people who, although they have been persecuted by the Communist system for years and years, remain Communism's greatest defenders. I find that embarrassing and very sad. A second kind of nonsense comes from Western politicians, politicians who live in free democracies. They understand the importance of freedom themselves, they enjoy that freedom, and yet they persist in defending Communist tyranny.

The second time I was in jail, before I was officially given a fourteen-year sentence, some of my jailers said, "What's the point of you fighting like this? Your so-called friends in the United States are very good friends with our leader. They are in a pact together. You are wasting your time." At the time I refused to believe them. But, now that I am outside, I am forced to believe because I have seen it with my own eyes.

I take strength from ordinary people, in both China and America. Every person wants his or her dignity respected, regardless of where they come from. This provides a continuous source of strength for my work. Democracies respect their citizens more than tyrannies. If you do not fight tyranny, the tyrants will never let you have an ordinary life. You must either surrender to them, or you dedicate your life to something greater. I try to reach people in the democracies, asking them to call upon their governments to see the Chinese Communist government as it really is. I haven't been successful yet, but at least this work has begun.

It is impossible to balance personal life and commitment to your country when you face such a massive oppressor. Your responsibility has to be with those who suffer. If you do not resist, the oppressors will never permit you to exist. So there is no way to achieve a balance—you simply have to give your life to the larger responsibility.

It is normal to protect oneself first. It is understandable. According to my younger brother and sister, I am an abnormal man. Before you embark on such a path you have to make a decision, you have to make a choice. My father was a leading general, so with my background I could easily enjoy the same privileges as other princelings currently enjoying the life of the rich in China. But I made the choice.

The time was December 1978. To make a decision like this, there is never one reason, there are always several. I was traveling in the countryside and saw the peasants and their living conditions so horrible that if you had any sense of humanity left, you had to feel compassion, sympathy for them. I began traveling when I was sixteen, and from that point on was always on the road. I sought out any opportunity where I could improve other people's living conditions. In December 1978, Deng Xiaoping gave a famous speech that seemed to crush the beginnings of democracy. The people who were active in democracy were so intimidated by his message and the aftermath of that speech that they began to back off. And at that time, I made the decision to stand up to Deng Xiaoping.

Nineteen ninety-seven was another moment when I had to make a choice. I was still in jail and until then had refused to leave jail before finishing my sentence. Deng Xiaoping had given me the choice: if I admitted I was wrong I could have left at any time. I always refused to do so. In 1997 I learned that the overseas democracy movement was so badly battered that there was very little of it left. I felt that if I did not leave jail to organize the overseas democracy movement, there might not be an overseas democracy movement at all. Since I have been in the West, just a year and a half, I think there have been two small improvements. First, the United States led all the other countries in a resolution condemning China at the United Nations. Secondly, the UN seems to be more unified against cooperating with China.

When I was imprisoned, I felt a sense of solidarity with the suffering of imprisoned peasants whom I had met on my travels. I kept in mind that what I was doing was right, that it would help relieve those who suffered. I believed I would succeed. Those thoughts gave me hope.

In 1997, they beat me, put me in isolation, and took away all reading material. Under such conditions, a mind has no reference point; you become utterly confused. Many of those I knew in prison lost their minds. That was our captors' goal. Reading material is important, regardless of its content. It becomes a focal point and an effort; a way to give your mind direction. With no point of focus, you lose your mind. This is a very serious form of torture.

People from Beijing have a great sense of humor. Chinese people have always coped with tyranny through humor. They used humor to articulate the absurdity of their experiences. To me, I feel humor is my nature, and my best defense. There is another source of strength, the ability to protect your own dignity. That is very important, and the most difficult. You have to believe that what you are doing is right. If you believe in what you are doing, then all the suffering becomes secondary.

If you cannot prepare yourself for death, then you should not decide to defy the regime, and once you are prepared to die, you don't really look at your efforts in terms of success or failure. You look at it as a choice of doing the right thing. In my family, you take responsibility for what you do. That influenced me. Once you make the decision, you know there is a price.

Luckily, I come from a family of very stubborn people, so facing danger and facing repression is normal to me. At a crucial moment, some people think of their own survival, and they give up their dignity, their purpose, their ideals.

These people seem very weak. But when you think of doing it not only for yourself but for the dignity of others, then you know what you are doing is right. At that point, courage becomes richer. For a month I was sentenced to death and I had great fear. Then I thought to myself, "I will die anyway. Why die as a laughing stock to my enemies?" So I controlled my fear in that moment of crisis, and that moment passed. I held onto my dignity. Some courage is both physical and mental. Some people are simply born with it. Some people when facing danger start shaking, uncontrollably.

One should not look down at people like that because there's a bodily reaction and some people are just born with physical courage. Ever since I was very young, I had no physical fear—very little physical fear. The two most consistent comments from my grade school report cards were that I was stubborn, and that I had no fear. Of course, Chinese teachers don't like these two traits in their students.

Nobody is always right. So when you look at anything you always have to maintain a fair mind. When you yourself are wrong, you have to admit to it. Then reconciliation is easier. You have to be honest. I have locked horns with Chinese Communist leaders but none of them has ever questioned what I say. They hate me. They fear me. But they don't question what I say. Even the policemen in my prison regarded me in this way. Some even asked me for advice because they knew that I would tell them the truth. If you do that consistently, you can go anywhere. It reconciles people. You must demonstrate your trustworthiness. Through all these decades of fighting Communist leaders, there is not a single one who has ever accused me of lying. If you have finally achieved the reputation of fair-mindedness, even your enemy can come to trust you. This allows you to have a balanced life.

HELEN PREJEAN

UNITED STATES

THE DEATH PENALTY

"Patrick was dead, but I didn't have a choice. That day, my mission
was born. It was just something I had to do because I knew
I was a primary witness and I would take people there through my stories.
So for fifteen years I have been working to stop the death penalty."

*Louisiana, 1977. Brothers Patrick and Eddie Sonnier admitted mugging David
LeBlanc, age seventeen, and Loretta Bourque, eighteen, one autumn night, but
each blamed the other for murdering them and raping Bourque. Eddie was sen-
tenced to life, Patrick to death by electrocution. In the summer of 1982, Sister
Helen Prejean had moved into St. Thomas Housing Project, one of New
Orleans's most violent neighborhoods, when a friend asked her to be a pen pal
to Pat Sonnier. Viewing the proposal as an extension of her ministry to the poor,
Prejean agreed, and opened her eyes to the underworld of life on death row. She
accompanied Sonnier through the next two years, until the day the state shaved
his head for the electrodes, strapped him into the chair, and executed him. Thus
began for Prejean a lifetime commitment to the abolition of the death penalty.
She recorded her experiences in her deeply moving best-selling book,* Dead Man
Walking. *Made into an acclaimed motion picture (for which Susan Sarandon
won an Oscar in 1995 for her portrayal of Sister Helen), the book and movie's
publicity propelled Prejean's worldwide campaign against capital punishment.
The United States is the only western country that administers the death penal-
ty: nearly four hundred people currently await executions there. Meanwhile, rec-
ognizing the needs also of the families of victims of violent crimes, Prejean also
created SURVIVE, an advocacy group with which she continues to work closely.*

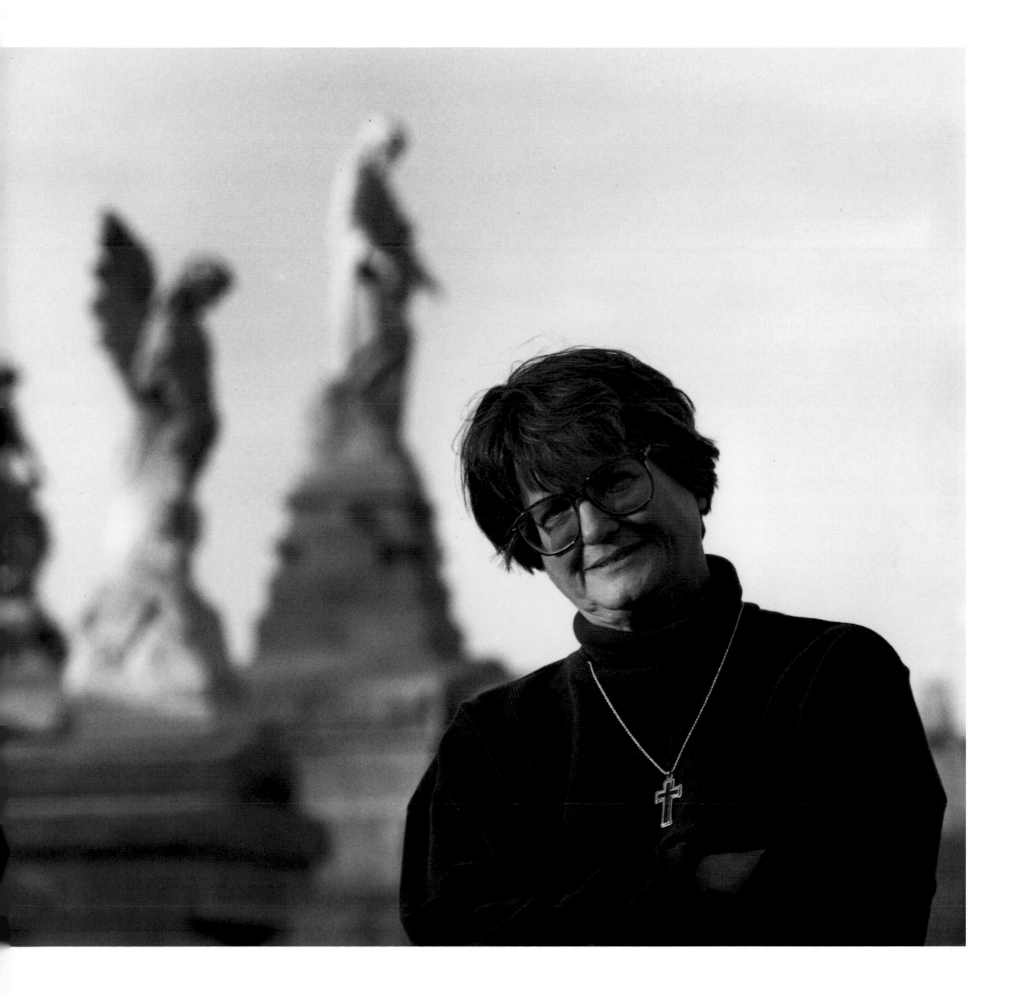

The death penalty legalizes the torture and killing of our own citizens and imitates their violence in order to deter or punish. I came to this realization only after my first witnessing of a state execution. When I came out of that execution chamber with Patrick, I was clear, clear inside. You are either paralyzed by something like that or you are galvanized. And I call being galvanized the resurrection principle of life—overcoming death, and resisting evil. You know how Gandhi said you have to expose evil and you have to actively resist? That day, my mission was born. Patrick was dead but I didn't have a choice. It was just something I had to do because I knew I was a primary witness and I would take people there through my stories. So for fifteen years I have been working to stop the death penalty.

But I see in my audience a distancing from the death penalty: "This is off my radar screen, these are just a few criminals." You have to bring people over to the victims. You've got to deal with outrage. When people meet a criminal through a story and then meet the victims and see what really helps victims to heal and what doesn't help victims to heal, at the end of it many people are crying. Even though they know the person has done a terrible crime, the experience of the dignity of a human being is there, also. That's why it was so hard to kill Karla Faye Tucker, because so many people met her on *Larry King Live*. You could see this was a loving woman. Yet the only thing we knew to do was freeze-frame her in the worst act of her life, judge her by that act—and kill her.

The death penalty is not a peripheral issue about what to do about a few criminals who have done terrible crimes. It epitomizes the three deepest wounds in our society that we need to attend to and heal. The first wound is racism, because the criminal justice system is permeated with racism—starting with who is a victim, and who cares. When white people are killed that is always considered the greatest crime in this country. So 85 percent of the people chosen for death are there because they killed white people. A recent study in Pennsylvania shows that racism also shows up in the disproportionate punishment given people of color who do the same crimes that white people do.

The second wound is the assault on the poor. It is not an accident that the thirty-six hundred people selected for death in this country are all poor. They don't have the resources to get a Johnny Cochran defense team. It is not an equal playing field when they go into court. Supposedly, in our adversarial system, you have the prosecution and you have the defense. The jury is going to listen to arguments from both sides and make a decision. But all the resources are on the prosecution side and when the defense comes in, they can rarely prevail. We consider it poor people's individual deficiency that accounts for their poverty. In Europe they have much more of a social sense. If crime begins to proliferate they ask, "What are we doing wrong as a society?" They look at the fabric. They look at the soil. In America we think, "That apple is bad, get another barrel, burn the bad apples."

The third wound is our penchant to try to solve social problems through violence. We have been doing this for a long time. Our country was built on violence: violence against slaves, violence against Native Americans, and the kind of violence born by not allowing everyone to have a voice—such as women who, for a long time, could not vote.

That is why I don't consider execution a peripheral issue; I consider it central to the social fabric of our country, and an act of profound despair. We don't know what else to do, so we imitate criminals' worst possible behavior. We kill people who kill other people because we say, "You don't deserve to live a life. You aren't human the way the rest of us are, so you are disposable." It's a very dangerous, pernicious attitude. It leads to the death of our citizens in other ways, too. You see, the death penalty is very explicit. We take people who are alive through a process of torture and then kill them.

This begins on a personal level with all of us; we need to be involved in trying to change what we know is wrong. Consciousness is the first step, and the way that happened to me was to get to know people. In our society people wear four sets of gloves. We don't touch each other. We avoid certain neighborhoods. We never go to prisons. Death row is far away from us. We never see criminals—they are distant from us. So it is easy to do anything to them. Look how quickly that affects how we think and act. Right now a key way for politicians to get points is to outdo each other in mandating harsh punishments for criminals.

The U.S. Supreme Court has upheld that it is not against the dignity of a human person to execute them. Amnesty International defines torture as an extreme mental or physical assault on someone rendered defenseless. Then take a scenario where we hear of a crime that someone took their victim and kept them locked in a house and told them, "We are gonna execute you, we are gonna shoot you in the head Tuesday night at 9:00," and then when it comes to 7:00 they bring the victim out and say, "Not tonight, another night." And they bring the person back and they wait again, they take the person out and put the gun to him and say, "Not tonight." And then add to this that their family is watching while this happens. This is the practice of torture—this is the death penalty. Some people have been brought to the death chamber just an hour from death and received a stay of execution—knowing it might happen again.

One of the things I have found that drives the death penalty is people's concern for safety: "If we don't execute them, they are going to get out in a few years and they are going to kill again." It is important for them to know that most states have long-term sentences, either life without parole or mandatory long-term sentences for people who have been convicted of felony murder or first-degree murder. We can be safe without imitating violence.

Similarly, the death penalty does not make a criminal remorseful. Remorse has to do with a personal transformation, empathy, and compassion, and the ability to experience the victim's pain and say, "I am sorry." Some of the people who have committed terrible crimes are limited in their capacity to empathize with other human beings, because in their whole life they had never received that kind of love. And death coming at them does not increase that capacity to feel for others. In fact it can have the opposite effect, because their life is threatened. Self-preservation kicks in. They wrap around themselves tighter and have less capacity to love or to feel for others.

You know the root of *forgive*? It means "give before," fore-give. Which means that you are perpetually in a stance of love—that the evil and hatred are not going to overcome you. Some people have a lot of trouble with that: the connotation of forgive and forget, and, closely connected to it, healing and closure.

With the victims' families in Oklahoma City I will always remember one man who stood up in the midst of the sharing and he said, "Let's not use that word *closure* anymore." He said, "By God's grace we can get back on the current of life, I can learn to cope. But there is not a day in life that I will not think of my daughter. And closure sounds like we have closed that chapter, almost like it is a compartmentalization." I have known victims' families who would rather use the word *reconciliation*: "I can reconcile myself into a love stance. But forgiveness sounds like it is okay. And I can never say that."

How did Hemingway put it? "Courage is grace under pressure." Courage for me is very close to integrity. It means doing what you need to. Acting. Getting out there to change things. I don't call it courage when I accompany someone to execution. That is an act of love. Though they may be courageous in the way they go to their death, holding on to their dignity when they die. But for me, courage comes more in tackling the American system and believing and hoping in people so that we continue to change things. Courage is that steadfastness to continue—even if it means that you are going to be threatened. Like when we did our first walks in Louisiana we would get these threatening calls, "You bleeding-heart liberal, you murder-loving people," or "I'm gonna give a donation to the group in the form of quarters that are going to be melted down into bullets." And cars stopped, and people gave you the finger, and they yelled at you. Because violence really does trigger violence. The whole thing of execution is, "Get him, get him."

My dream is that human rights is what's going to bring us into the new millennium, that the more and more we grow into the sense of our community, our respect for each other, the dignity of people, that we can learn much better how to build a society. It comes back to me, the goodness, and that goodness inspires, energizes. You know how when Jesus was executed he said, "Father forgive them, they know not what they are doing?" I really think that that lack of consciousness and awareness is what makes us so insensitive to each other, and so we do these things to each other. If we bring people to consciousness and their own best hearts, they will respond. And so that is what we have to do.

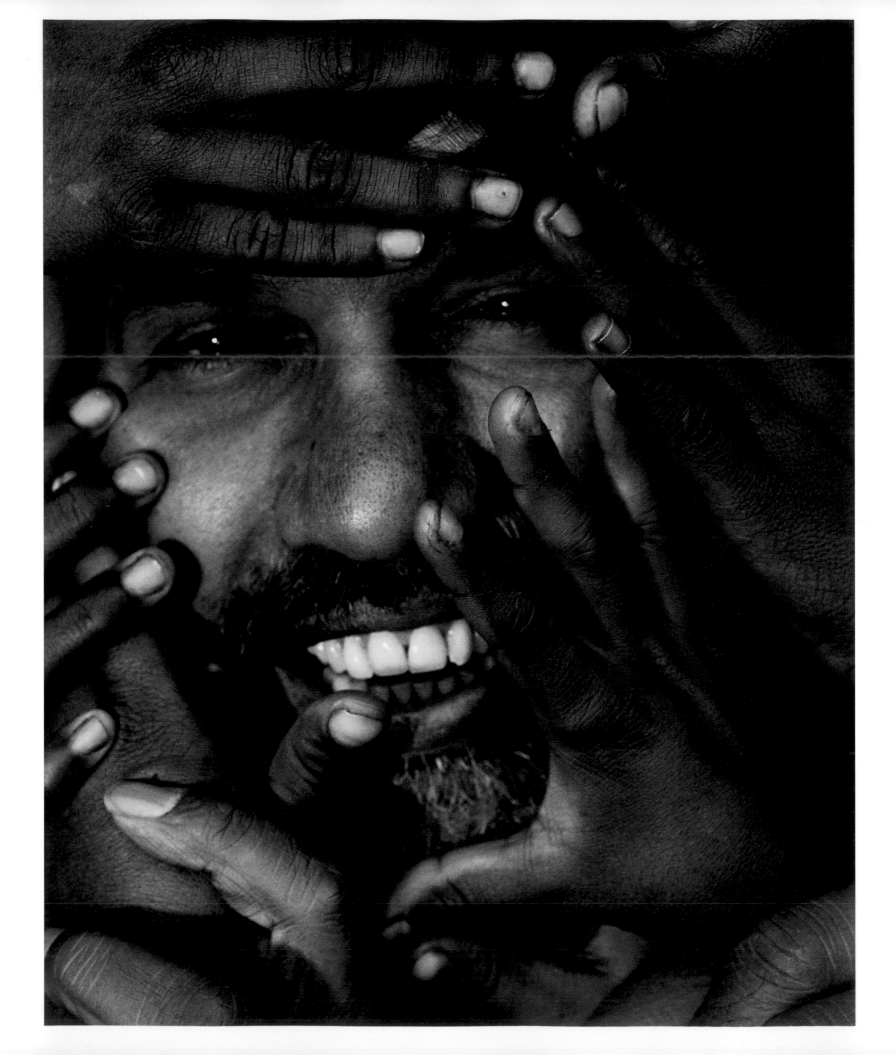

KAILASH SATYARTHI

INDIA

——————

CHILD LABOR

"Small children of six, seven years and older are forced to work fourteen hours a day, without breaks or a day of rest. If they cry for their parents, they are beaten severely, sometimes hanged upside down from the trees and even branded or burned with cigarettes."

Kailash Satyarthi is India's lodestar for the abolition of child labor. Over the last decade he has emancipated over 40,000 people, including 28,000 children from bonded labor, a form of slavery where a desperate family typically borrows needed funds from a lender (sums as little as $35) and is forced to hand over a child as surety until the funds can be repaid. But often the money can never be repaid—and the child is sold and resold to different masters. Bonded laborers work in the diamond, stonecutting, manufacturing, and other industries. They are especially prevalent in the carpet export business, where they hand-knot rugs for the U.S. and other markets. Satyarthi rescues children and women from enslavement in the overcrowded, filthy, and isolated factories where conditions are deplorable, with inhuman hours, unsafe workplaces, rampant torture, and sexual assault. Satyarthi is now out on bail on false charges brought against him by a disgruntled carpet export company executive after Satyarthi appeared on an exposé aired on European television. The constant death threats are taken seriously—two of Satyarthi's colleagues have been murdered. Satyarthi heads the South Asian Coalition on Child Servitude, which he cofounded in 1989. Under his leadership, SACCS carries out public awareness campaigns, advocacy, legal actions, and direct intervention to emancipate children and women from bonded and child labor. SACCS rallies national and international institutions and nongovernmental organizations to bring pressure on governments, manufacturers, and importers to stop exploiting illegal labor. Satyarthi organized and led two great marches across India to raise awareness about child labor, and, in 1998, organized over ten thou-

sand NGOs around the world to participate in the Global March Against Child Labor. Still there is much to do. There are 6 to 10 million children in bonded labor in India alone. There are 250 million children forced into child labor across the world, including 246,000 children working at agricultural labor and in sweatshops in the United States. Satyarthi's job has just begun.

Bonded labor is a form of modern-day slavery, where ordinary people lose the most basic freedom of movement, the freedom of choice. They are forced to work long hours with little rest. Over five million children are born into such slavery. Their parents or grandparents may have borrowed a petty sum from a local landlord and consequently generations and generations have to work for the same master. They are prisoners—forbidden to leave. Another five million children are sent to work when their parents receive a token advance and this small amount is used to justify unending years of hardship.

The conditions of bonded labor are completely inhuman. Small children of six, seven years and older are forced to work fourteen hours a day, without breaks or a day of rest. If they cry for their parents, they are beaten severely, sometimes hanged upside down from the trees and even branded or burned with cigarettes. They are often kept half-fed because the employers feel that if they are fed properly, then they will be sleepy and slow in their work. In many cases they are not even permitted to talk to each other or laugh out loud because it makes the work less efficient. It is real medieval slavery.

We believe that no other forms of human rights violation can be worse than this. This is the most shameful defeat of Indian law, our country's constitution and the United Nations Charter. Our most effective armor in this situation is to educate the masses and to create concern and awareness against this social evil. In addition, we attempt to identify areas where child slavery is common. We conduct secret raids to free these children and return them to their families. Follow-up on their education and rehabilitation is an equally vital step in the whole process. We lobby different sectors of society, parliamentarians, religious groups, trade unions, and others, who we believe could influence the situation. We have about a hundred full-time and part-time associates in our group. But we have also formed a network of over 470 nongovernmental organizations in India and other South Asian countries.

For us, working with enslaved children has never been an easy task. It very often involves quite traumatic situations. These children have been in bondage ever since the time they can remember. Liberty for them is an unfamiliar word. They don't know what it is like to be "free." For us, the foremost challenge is to return to them their lost childhood. It is not as simple as it might sound—we really have to work hard at it. For instance, one of the children we've freed was a fourteen-year-old boy, Nageshwar, who was found branded with red-hot iron rods. Coincidentally, at that time, an official from the RFK Center for Human Rights was in India and she came across the boy in New Delhi. The trauma Nageshwar went through had made him lose his speech. He was even unable to explain his condition. It was only later through other children that we came to know about what had happened to him. We really have to work hard to reach such children.

As you may be well aware, marches and walks have been an integral part of our Indian tradition. Mahatma Gandhi marched several times to educate the people (and also to learn something himself!). Keeping in view their strong impact, especially when it comes to mass mobilization, marches have always occupied a prominent place in our overall strategy to combat child slavery. Marching doesn't

mean that we are trying to impose anything. Our demonstrations have about 200 to 250 marchers, half of whom are children—children who have been freed from bondage and slavery. They act as living examples of the dire need to educate people about both the negative impact of the bonded labor system and the positive impact of their newly gained freedom. The other marchers are representatives from human rights organizations, trade unions, and social organizations who join in solidarity. We go to different villages every day, and conduct public meetings, street theater, cultural activities, and press conferences to put across our message to the people.

Two years ago we welcomed the prime minister's promise to act against child labor, if not against bonded labor. We were hoping for some positive results, some impetus to reforms. But even after all this time, no action has taken place. It is very unfortunate. The pronouncement initially created some fear in the minds of employers, but now it is going to prove counterproductive to reform. People by now realized it was nothing more than a political gimmick and that there was no real will behind it. The employees are a varied lot. When a child is bonded to a street restaurant, the employer is usually an ordinary person of some remote village or town. But when children are employed in carpet weaving, or the glass industry or the brassware industry, the employers are "big" people. They generate a lot of foreign exchange through exports and are always considered favorably by the government.

Despite this, I am not in favor of a total boycott or blanket ban on the export of Indian carpets. Instead I have suggested that consumers buy only those carpets that are guaranteed made without child labor. Consumer education is a must to generate demand for such carpets. We believe that if more and more consumers pressed this issue, more and more employers would be compelled to free child workers and replace them with adults. It is unfortunate that in the last few years in India, Pakistan, and Nepal, the numbers of children in servitude have gone up,

> "These children have been in bondage ever since the time they can remember. Liberty for them is an unfamiliar word. They don't know what it is like to be 'free.' For us, the foremost challenge is to return to them their lost childhood."

paralleling the growth in exports. For instance, today in India we have about 300,000 children in the carpet industry alone with the export market of over U.S. $600 million a year. Ten or fifteen years ago, the number of children was somewhere between 75,000 to 100,000 and at that time the exports were not for more than U.S. $100 million. The direct relation between these two is clearly evident. This fact compelled us to launch a consumer campaign abroad. Health and environment have been the prime concerns among the consumers in the West—in Germany, in the U.S. But the issue of children was never linked with this consumer consciousness. People thought of environment and animal rights, but they never thought about children. But in the last couple years, I am proud that the child labor issue has gained momentum and has become one of the big campaigns in the world. What began with awareness and publicity has now expanded to issues of compliance.

We have recommended the establishment of an independent and professional, internationally credible body to inspect, monitor, and finally certify carpets and other products have been made without child labor. We formed the Rugmark Foundation as an independent body with nongovernmental organizations like UNICEF. They appoint field inspectors, and give all carpets a quote number that gives the details of the production history of the carpet. The labels are woven in the backside of the carpet, and nobody can remove or replace them. This is a significant step in ending this exploitation.

But even this task of educating Western consumers is not so easy. It does involve its share of risks. For example, a German TV film company, after initial research, exposed the employment of children in the carpet export industry. The story was of an importer in Germany, IKEA, who had announced that they would deal only with child-labor-free goods. So reporters started investigating. They came to my office and ashram and interviewed me. Their interview was of a very general nature but when the film was shown later it mentioned Sheena Export in detail, which resulted in the cancellation of a big

order from IKEA. Sheena Export, one of the biggest players in the field, became notorious, which affected their exports to other countries, including the United States, which was worth U.S. $200 million a year. The company is politically very powerful (one of the brothers is the transport minister in the state of Haryana) and so they decided to fight back.

I know that the entire carpet industry, or the majority of it, opposes me. They believe I am their enemy; they just want to eliminate me. They wanted to take me to Haryana, the state known for the worst human rights violations, fake encounters, illegal custody, and killings of people in jail and in police stations. I was arrested on June 1. They wanted to arrest me legally, but they never informed the Delhi police, which is required under Indian law. Because the police came from another state and had no jurisdiction, they couldn't legally arrest me in my home in Delhi. But they tried. I was able to make phone calls and consult a few people on this, and finally I told them that they could not arrest me. The Haryana police did not pay any attention and threatened to break in. They took out their pistols. As you can imagine, their presence had created terror in the whole neighborhood. I was finally arrested and later released on bail. It was not the first time, though it was the first that such a big plot was cooked up against me. At times in the past I have faced such threats. Two of my colleagues have also been killed.

I think of it all as a test. This is a moral examination that one has to pass. If you decide to stand up against such social evils, you have to be fully prepared—not just physically or mentally, but also spiritually. One has to pull oneself together for the supreme sacrifice—and people have done so in the past. Robert F. Kennedy did, Mahatma Gandhi, Indira Gandhi, John Kennedy—the list can go on endlessly. Resistance—it is there always, we only have to prepare ourselves for it. We will have to face it, sooner or later. It is the history of humanity, after all.

PATRIA JIMÉNEZ

MEXICO

GAY, LESBIAN, AND TRANSGENDER RIGHTS

"We have to force the government to provide equal treatment, to stop discrimination, to respect the right to health care and a job for gays. In order to exercise these rights you have to demand them."

Mexico's first openly homosexual member of Congress, Patria Jiménez Flores was elected in 1998 at the age of forty-one. The ninth of ten children in a conservative Catholic family, Jiménez overcame her own family's prejudices to confront the bigotry of society at large. She works on issues of homophobic violence, violations of basic rights, sexual and sexuality education, cultural activism, and awareness of AIDS and other sexually transmitted diseases. In addition she is a leader on domestic violence initiatives and a supporter of peace negotiations with the Zapatista rebels in Chiapas. As a member of the national legislature, Jiménez works on behalf of sexual minorities, and for the dispossessed and voiceless throughout Mexico. Between 1991 and 1993, some twenty-five gay men were assassinated in Mexico, mostly among the Chiapas transvestite community. Jiménez has been a relentless advocate for justice, pressuring police to reopen the investigations. On the day of this interview, Jiménez was on the phone to Chiapas, hearing from local human rights organizers that authorities had used violence again that morning, and her presence would help prevent confrontation. Could she possibly come in time for the demonstration? Despite the caseload of legislation confronting her, Patria Jiménez was on the next flight.

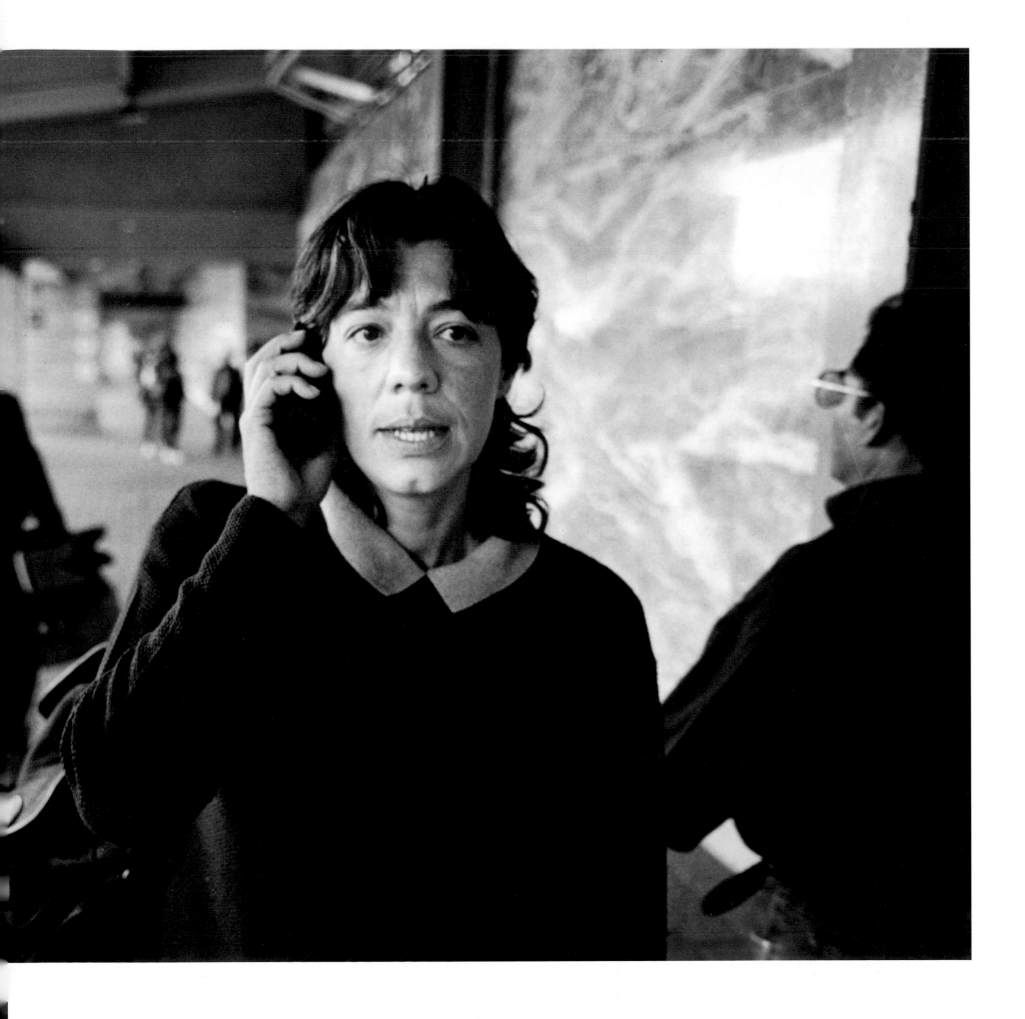

Twenty-five transvestites were executed, one by one, in the state of Chiapas. The murders were carried out with high-powered weapons, those reserved for the exclusive use of the armed forces and the judicial police. There was a private party at which someone allegedly made a video, so what the governor allegedly did was to kill all the people who may have had something to do with that. And while violent discrimination is more pronounced in municipalities with a right-wing party in power, other states within Mexico have had their share of human rights violations against gay, lesbian, or transgendered people.

In Mexico City, with the election of the new government (the Party of the Democratic Revolution), we saw a change to greater visibility and freedom of expression. Proposals we made to improve the human rights situation of sexually diverse people included the creation of the first community center for them. We could have done it alone, but it was important to have government support. This is an ongoing struggle.

I have been a lesbian activist for twenty years. I think that not feeling guilty about it, not having to request permission simply to live without hiding, is liberating. I don't know if it's a consciousness that you learn. I certainly was strengthened by feminist discourse, by finding groups of women who reflected on everything—sexual roles, the division of labor, violence. What I learned is that you can't discriminate on the basis of a human condition. You can't ask a Chinese person to have round eyes, or someone to change their skin color, or a homosexual to be heterosexual. But in my culture this truth is not universally acknowledged.

It starts, of course, in the home, this phenomenon of family violence against children who are gay. It begins with silence, with marginalization within the family environment, with punishment. By brothers, fathers, uncles. In a minor, small way, I felt this while growing up, too. Family conversation was always negative when it came to the issue of homosexuals. And, of course, that's what makes someone repress the idea that he or she is a homosexual.

Let me tell you one story. At one point, one of my brothers was threatened by my relationship with one of his girlfriends. She had written me a letter, and he opened it before I did—because he was jealous, I suppose. Of course, I wasn't involved with his friend in any way. I was only sixteen at the time, and he was maybe nineteen. At that point I still didn't have any idea that I was a lesbian. And this letter didn't really say anything special, but after reading it my brother spoke to me in really offensive terms. "You fucking lesbian," he said. I responded, "But why 'fucking'? And I don't understand—what's wrong with being a lesbian? Why is it an offense?" I didn't like his attitude. Furthermore, I knew it showed a lack of respect to read my letter. It was my first experience of rebellion, of responding to the prejudices of the larger society we live in, of personal anger.

You see, I was never in the closet. I left home so they wouldn't try to take me to a psychologist or psychiatrist. But when I did finally leave home I was out in the streets—literally—marching and proclaiming who I was. The first demonstration I went to I unfurled a poster at the Iranian Embassy, because they were killing women who took off their veils. It was a big sign saying: "Mexican Lesbians Against

"My fear disappears when I begin to speak in these situations, without raising my voice....I'm afraid inside, but calm outside. It's only when I get home that I react. The morning after, I wake up and say, 'What did I do?'"

the Assassination of Iranian Women." People looked at it, and came back to look again. We always took the opportunity to forthrightly declare that we were lesbians protesting this or that. Because I believe it is very important to get involved within social movements as lesbians, homosexuals, and bisexuals, and to work within them, like the indigenous movement in Mexico, for example. That gave us presence, and made us, and them, realize that one is not alone.

In my life I have heard a lot of stories from women. Stories that explain what it means to live a gay, lesbian, bisexual, or transgendered life, with all its disadvantages, in such a heterosexist society. I began late in the 1970s to consider ways to solve problems or, at least, to diminish the levels of anxiety with which gay people lived.

By the time I actually had lesbian relationships, I was already very independent. I left home because I knew I would not be able to change my entire family, and it was always a given that they were going to try to change me. I tried to write them a letter saying I thought I had already learned everything that I could from my family, and everything I had left to learn was beyond the boundaries of our closed world. That was a crisis for them. My sisters told my mother I had a sexual deviation problem. But by the time they actually reacted, I was already gone. Later, I rebuilt my relationship with my mother. She imagined that my world was full of problems, that I would never have a home. But I showed her that I had a house and a job, and that I had continued studying. And when we finally sat down face to face to talk, she said to me that the only thing she wanted to know is whether I

was happy. Then she said, "But why can't you be like your sisters?" And I responded, "Would you really want their lives for me?"

Still, my whole life I always felt my mother's support, her love. Parents always know if their children are gay. With me, my mother never spoke about gay issues, but she'd buy me a pair of pants, or a particular shirt, as though she knew. And she seemed to understand that what I was doing was right for me.

With being lesbian comes the pressure of tremendous responsibility. There's always a pressure to show that we're better. I don't know if it's positive or negative, but we strive to be the best we can at work. It's part of our seeking acceptance and I like to think that through this effort we can support and help other lesbians. Part of my effort is to show that I'm qualified. Though I don't actively feel discrimination, because I think I've done my job well, I recognize that discrimination is impregnated in daily life. It can be felt in the way people look at you.

Here's one example. In Orizábal, in the state of Veracruz, the mayor decided to detain all transsexuals who are prostitutes. So what did they do? They picked up the prostitutes, and all the gays and lesbians, too. How did they pick them up? By their appearance alone. The prostitutes were liable to be picked up for actions, administrative violations: for selling their bodies, for lascivious conduct. But lots of young gay people were brought to jail solely because of their appearance. Similarly, if young people were caught carrying condoms, they were accused of prostitution.

PATRIA JIMÉNEZ

There is discrimination. In Mexico City and the other big cities, gay people gain strength from being part of a group. But elsewhere in Mexico, people are alone and isolated. When someone in this situation gets our telephone number, they call us; and today, we get hundreds of calls. The movement has done a lot, providing services, creating groups, supporting sexual diversity.

But there is much more to accomplish. What I would like to do through radio and television programs is to get families to know that they should not discriminate against their children. We're pushing for a climate in which young gay men and lesbians can have positive relations with their families and friends.

But there is an outside world, too, to contend with. It's still a reality that someone gay could lose their job if it becomes known. A professional, a cardiologist, even someone of real eminence can be fingered as a homosexual by anyone on the street. The professional then might lose his or her job. Still. Today. That's why we need legislation. This is a process that has been evolving, the understanding that it is important for gay people to know that they have rights. For twenty years that's been our work—to explain that we are citizens, that we pay taxes. And now that sexually diverse communities understand that they have the same rights as everyone else, our work is to get them to exercise their rights. We're just at the point where gay people know that we have power. We surprised ourselves when we proposed to march to the center of Mexico City during the annual demonstration. People showed up by the thousands and said, "Yes, we are citizens." It was an important step in the process we are living now. We can't reach all gay people in Mexico, but our organization is becoming more accessible all the time. But we have to force the government—it doesn't matter if it is the National Action Party, the Institutional Revolutionary Party, or the Party of the Democratic Revolution—to provide equal treatment, to stop discrimination, to respect the right to health care and a job for gays. In order to exercise these rights you have to demand them.

But things are slowly changing—and for the better. We've reached agreements related to young people unable to finish their studies because of their sexual orientation, as in the case of transgendered people, who often feel that their only option is prostitution. We're discussing this with authorities on the district level, so that when transgendered people arrive, dressed however, they are not discriminated against. They should be treated as citizens with access to this type of privileges, scholarships, and services that the government gives to other people, so they can have a trade. And we've had a positive response. We've also asked on a district level for the establishment of places to sell condoms in public, to help limit the spread of HIV, along with a person who can dispense information, but at this time even basic salaries are not sufficient to purchase condoms.

We succeeded in establishing the office of the Social Ombudsman, who receives complaints from citizens, gives support, investigates complaints, and punishes wrongdoers. They are going to open a window for people to lodge complaints, related to sexual diversity—whether you were fired or kicked out of your school or your apartment, or suffered some physical attack. They'll work on your case and give you advice—without discrimination. These are the things we have seen on the positive side of the balance.

"You can't ask a Chinese person to have round eyes, or someone to change their skin color, or a homosexual to be heterosexual. But in my culture this truth is not universally acknowledged."

There have been some interesting developments in working with the men and women members of the Chamber of Deputies. We eliminated the terms "homosexualism" and "homosexual practices" from the legal vocabulary (considered under the criminal code to be aggravating factors in the crime of corrupting minors). Representatives from all political parties accepted this change as natural and normal at the negotiating table. They said it was fine, a good proposal, and moved it forward to the Senate. In Mexico City, it will also be approved. So progress has been made.

The right-wing National Action Party and the Church have led powerful attacks against gays and lesbians. We requested a meeting with Church leaders to ask them to stop discriminating against sexually diverse people. There was no response, so I made a proposal to groups of religious people (who happen to be gay) to make a pilgrimage to the Virgin of Guadalupe. It was a great initiative, because we will reclaim the right to be spiritual, to profess a religion, without having to worry about the religious hierarchy. When I look back on this, I will know I did the best that I possibly could. For my private life, I steal time. I don't really have time, just little pieces, days, sometimes hours. My work schedule includes lesbian groups, the lesbian-gay movement, my work in Congress, the legislative initiatives on which I work, marches, meetings, protests, publishing a magazine, writing. Plus the congressional commissions on which I sit—which are important for me: equality and gender, human rights, and population and development. But I just don't have time for everything.

And I will look back and realize the true meanings of many things, like courage. Courage is when, in Chiapas, you ask a general to remove his troops from a com-

munity because they are entering houses at night, frightening people. You have to talk to that general, to confront someone with weapons and power, to overcome your timidity and fear. Today they tell me I'm going to Chiapas, to lead the people on a march into the community of La Realidad. When we get to the roadblock, there will be armed paramilitaries. These are the most risky situations: entering communities in which my truck is surrounded by paramilitaries threatening to burn it, saying that they will kill us. It used to make me afraid, but it doesn't any more. Because I am never alone. Even when people ask me to go in front, to confront the troops or the paramilitaries, they come with me, so we're a group.

My fear disappears when I begin to speak in these situations, without raising my voice. I just try to explain to people what's going on. I'm afraid inside, but calm outside. It's only when I get home that I react. The morning after, I wake up and say, "What did I do?" That could be brave. I don't know. I'm not someone who takes risks. Others have been beaten up, but this has not happened to me. If that happens to me some day, it will be part of the work. I just hope they don't hurt me too badly.

But I take courage by realizing that here is an opening, and we have been able to move forward on difficult cases. I've gotten a reputation of being a good advocate. But it works because there is openness on the part of the other side. They are small cases, but they are very important, because they have to do with people's lives—someone in jail, rape victims, a pregnant woman, a person kicked out of work after twenty-five years. Very small cases, but it's their lives. And it's so worth fighting for.

GABOR GOMBOS

HUNGARY

MENTAL DISABILITIES RIGHTS

"There was a relatively young man with severe mental retardation in the cage. We asked the staff how much time he spent in the cage. The answer was all day, except for half an hour when a staffer works with him. And I asked them, why do you keep this person in the cage?"

Throughout the world, people with mental retardation, elders with dementia, and people of all ages who suffer from psychological illnesses, from depression to schizophrenia, are regularly abandoned to a life of discrimination. They are often locked away in insane asylums where degrading conditions include pervasive inactivity, filthy spaces, and the use of physical restraints, including confinement to cages. Denied adequate privacy, medical and dental care, food, water, clothing, blankets, and heat; rehabilitation and reintegration into society are rarely the goals of their treatment, medications are chronically overused and misused, and there is almost a complete failure to provide informed consent for treatment and experimentation. The chronic shortage of resources includes a serious lack of trained staff, and few avenues of complaint for violations against this most vulnerable and marginalized segment of society. Gabor Gombos knows these conditions all too well. Between 1977 and 1990 he was confined four times to psychiatric wards in Hungarian hospitals. He emerged determined to overhaul psychiatric care, first in his country and then across Europe. To this end, Gombos cofounded the first NGO active in Hungarian mental health issues (EGISZ, the National Family Association of the Mentally Ill) in 1993, and the following year, cofounded Voice of Soul, Hungary's first NGO for ex-users and survivors of mental health facilities, where he still serves as chair of the board. Gombos is also a member of the board of directors of the Users, Ex-users, and Survivors of the Psychiatry Movement in Europe, and the European Network on Constraint and Collaboration in Psychiatry, and is on the editorial board of Out Loud. He is cofounder of the Hungarian Mental Health Interest Forum. Gabor Gombos's tireless work on behalf of people with mental illness has helped end the previous damaging and derogatory practices of that time and brought the human potential of those with mental disabilities into the light at last.

In Hungary, there are fifty-three social care homes for the mentally ill, similar to the old American state mental hospitals (as opposed to psychiatric hospitals and psychiatric wards, basically for acute patients, where patients spend at most two or three months). Most of these fifty-three institutions were started in 1953 by the Communist Party, which maintained that mental illness was a characteristic feature of capitalism, and would disappear under Communism. And after a few years they discovered there were still mentally disabled people in society. How to solve the problem? They set up these institutions very far from bigger cities and towns, to make mentally disabled people invisible for the majority of society. If you don't see them, they don't exist.

Depression is a nationwide problem as with everywhere in the civilized world. The Hungarian suicide rate is one of the highest suicide rates in the world.

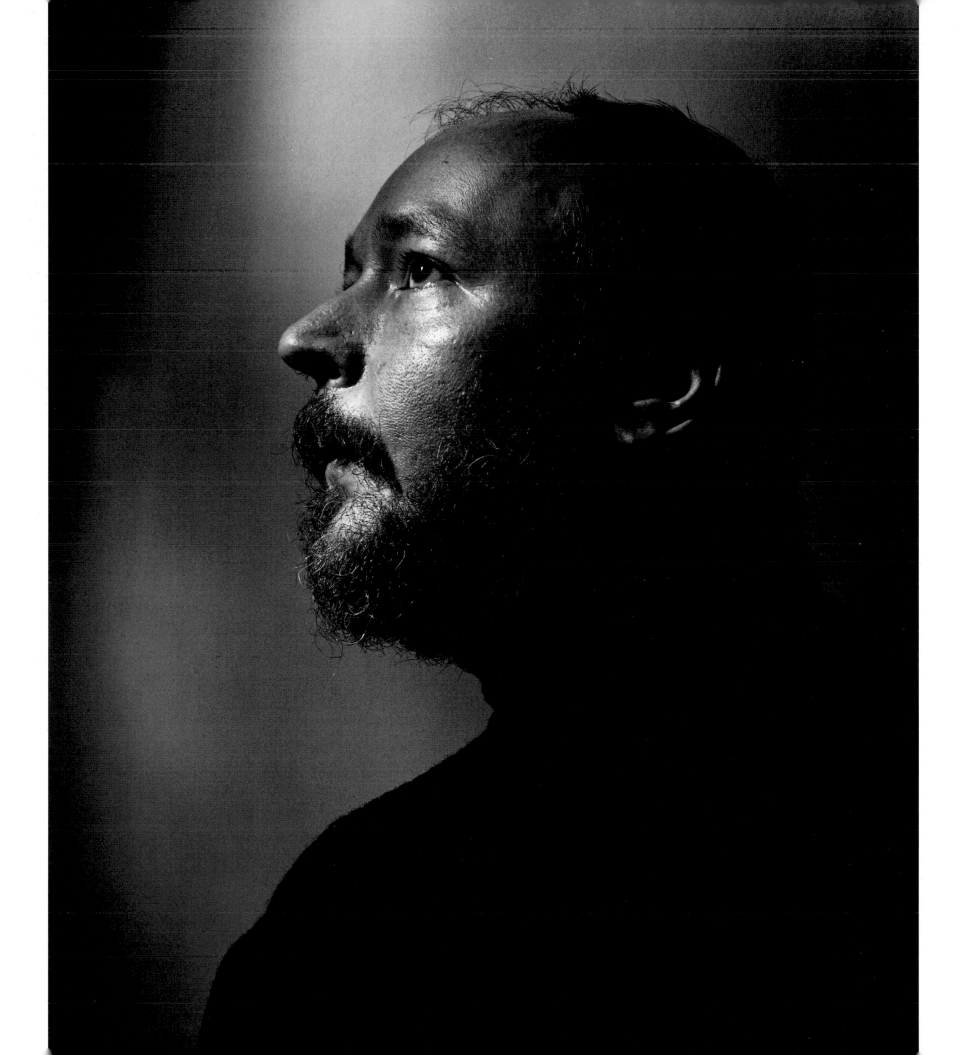

Classic psychiatric disorders (severe depression, manic depression, schizophrenia) are as prevalent everywhere. So we have 100,000 people with schizophrenia, another 100,000 people with severe depression or manic depression. There are a few thousand beds in psychiatric hospitals and wards, and a few thousand more in the homes for the mentally ill. Even the newest post-1994 facilities reflect the attitude of the society, the discrimination, the prejudice, the stigma against people with mental disabilities. The buildings are modern, but the attitudes are old, designed without rooms for occupational therapy, without a common eating facility, and with cages for acute cases.

What is missing is a flexible and reachable network of various social services for people with mental disabilities: a sheltered place to live, support in feeding, shopping, and other needs. But there are no outpatient services like that. With as little as half an hour a day, these people could be not only equal members of society but able to earn their own living. But because these services are completely missing, the only choice for the family or for the local authorities is to condemn people to social care homes for the mentally ill. This is really tragic. The lack of resources is not the main reason for the government's failure to do anything (a much-heard complaint) because an unreasonable amount is spent for services that are ineffective and (by the way) violate basic human rights. On a fact-finding trip to an institution, for example, we noticed a relatively young man with severe mental retardation in the cage. We asked the staff how much time he spent in the cage. The answer was all day, except for half an hour when a staffer works with him. And I asked them, why do you keep this person in the cage? And the answer was for his own protection.

The average waiting list for admittance to a group home is about three years, and if you consider that the conditions are abhorrent, that they are not rehabilitation institutions but are custodial institutions, it seems surprising that there are people waiting. It doesn't mean that these people want to be there; it means there is no other choice, or that their guardians are forcing them to be there. The Hungarian guardianship system itself is a severe violation of basic human rights. If someone has a psychiatric diagnosis or one of mental retardation and if someone therefore believes that person is incompetent, then they can initiate guardianship procedures, and some local official makes a decision about a temporary guardianship, lasting sometimes for two or three years. It means all your civil rights are controlled by your guardian, including your property, house, and money. Abuse is common.

Medically you can be forcibly treated or hospitalized against your will, only if you have been admitted voluntarily. The guardians circumvent this by proclaiming the patient incompetent and then condemn them for life to "voluntary" care. In the new social care homes for the mentally ill, more than 90 percent of the residents are under guardianship, and this is shameful.

One of the issues we address is occupational therapy. There is very little, and what exists is not very therapeutic. On the other hand, patients do real work for the institution cleaning bathrooms and washing floors—for free. They should be paid the minimum wage for this real custodial work they perform instead of being exploited by the institution. The fact that they perform these services indicates that they can survive perfectly well in society with minimal support.

"Even the newest post-1994 facilities
reflect the attitude of the society,
the discrimination, the prejudice, the stigma
against people with mental disabilities."

We walked through one facility for three hours with the psychiatrist, the director, the chief nurse, and others, and not one patient seemed to recognize or initiate conversation with any of the staff, as though they had no relationship. Yet this home is very proud that it has a psychiatrist at all since most of these institutions do not have one. The psychiatrist said he only needs to see patients with acute symptoms and only 5 percent are acute so he's there only three afternoons a week. My question was, why should the other patients live in social institutions designed for the mentally disabled? Why not in ordinary social care homes for the elderly, for instance? Or shelters for the homeless? I know the answer: because there are no alternative shelters. But how amazing that the chief psychiatrist said they don't need to see a psychiatrist. It's an insane asylum, after all…

A few words about institutions for mentally ill and mentally retarded people. I told you that most of the social care homes for the mentally ill are mixed institutions. And you can find people with mental retardation in every one of these places. I must tell you that, on average, the human rights violations in the institutions for the mentally retarded are much more severe. It's not a question of money and a shortage in financing. It's a question of attitudes. it's the exception when the staff beats a mentally ill person. But it's very often an everyday practice in many of these institutions for the mentally retarded that the staff beats some of the patients.

The last time I was in a mental hospital was in 1991. At that time I was very, very depressed, and I was a voluntary patient. But when I wanted to leave I was not allowed. Since we had no real legislation about this, the doctor simply changed my status in the medical documents to involuntary, because he decided I'd become agitated or confused—I don't know. The courts had nothing to do with this. The court made several visits to the wards. They interviewed some selected patients, most of whom were overdrugged and some of them had just been electroshocked. After the electroshock, your memory is not really clear. So they said, "Yes, yes, it's okay."

The main indication for electroshock is severe depression. Twenty years ago, the major indication was schizophrenia. Now they say that it's contraindicated in schizophrenia. My wife was electroshocked twenty-six times for schizophrenia, only to be told that it was a severe mistake. She is suffering long-term side effects from those electroshocks. I was lucky, because my mother protested against my treatment so I have never been shocked, just treated with drugs.

My contact with psychiatry began when I was three years old. My uncle committed suicide. A few months later, my mother became very depressed and delusional. She was hospitalized many times when I was a child, and when not in the hospital she worked outside the home to care for me and my grandmother. So I was raised mainly by my grandmother, who was also mentally ill. She died when I was ten. Being afraid that I'd be put in an orphanage, my mother married. But my stepfather drank a lot, which did not help my mother's emotional stability. Her hospitalizations increased and she tried to commit suicide several times. My mother lost her autonomy, her

social contacts, her social roles over time and applied for a disability pension. She lost her job, which was devastating for her. So her life was narrowing and narrowing and narrowing. And the only goal which remained for her was for me to grow me up successfully. As soon as I became more or less independent, my mother died. Her death was mysterious because she was an outpatient at the mental health hospital where she was an involuntary subject in a double-blind drug experiment.

When I discovered the true cause of her death, I went really crazy, completely psychotic, with threatening hallucinations. So psychotic that I didn't go to the psychiatrists. I didn't eat. I didn't leave my home. I couldn't. The reason that I am here is that one of my friends unexpectedly visited me, and discovered that I was visibly psychotic. But he was an old friend and didn't think that the answer to my state was hospitalization. He could understand my situation. I had lost my mother. He knew something about her very doubtful autopsy. So he moved into my apartment for weeks, spent all his time with me, forced me to eat something.

For weeks, I couldn't understand what he told me. He recognized this and didn't try to speak to me; he was just together with me. And that was what I really needed. After three weeks, I recognized that I had passed my deepest crisis. Without any help from the psychiatric establishment, with only the very human help from my friend, I had survived this very critical period.

That was the beginning of a new life. I began to question many things that I had believed in before. That resulted in another crisis. But now I had the self-confidence that, with the proper support from people who are close to me, I could survive. Before that, starting at age seventeen, when I felt ill, I had gone to the psychiatric institution more or less voluntarily and there I was treated as an object. I received some injections, some pills, was told to try to relax, that it had nothing to do with my disorder; that "we are trying to help you"; that "you cannot help yourself at all because it's the biochemistry of your brain." And I believed it. But when I emerged out of my second psychotic experience with my friend's help, I felt that I did have some control over my illness.

I had always tried in the past to find someone to make my decisions for me. I couldn't imagine that I would be the one to control my own life. It is not easy if you start when you are over twenty-five, but not impossible. Then I was lucky. I got a grant from the French Ministry of Culture for studies in metaphysics. So I did some research in France, four months in a completely strange environment, a very good opportunity to start a long, long dialogue with myself, to make certain things clear.

And then I understood that physics was not my real profession. It was a kind of medication in my childhood to have a goal, which was not easy at the time in Hungary, one that belonged to the elite professionals in the Communist countries. But when I came back from France, some people contacted me and asked me to help them organize a nongovernmental organization for the families of people

> "I remind myself that many of the mistakes in mental health care come from a helping attitude. But they want to help you without asking you, without understanding you, without involving you, 'in your best interest.'"

with mental disabilities. I joined because of my mother. And after a time, became more and more involved. I met my wife through these activities, and we decided to get married. And this was the moment when I realized that I would be seriously committed to helping people who share my terrible experience of so-called psychosis, and changing the way society reacts to it, and so changing the world.

The transition to teaching was hard. I have never suffered from a learning disability, but I suffered from very similar emotional deprivation, a violation of my emotional privacy. Now I am very involved in this movement, called Users, Ex-users and Survivors of the Psychiatry Movement in Europe. We say we are lucky to have survived a very antihuman mechanism which doesn't kill the patients biologically, but the end result is very often a socially dead person living in a social care home for the mentally ill. I had a very simple choice: Did I want to take up this role and have a chance to find myself? Or not take up this mission and lose that chance?

For years I believed that it was my mission to do research in physics. There were extremely heavy competitors there, but not supporters. In my private life, my mother was the only person who was a supporter. My real father never supported me; my grandmother maybe wanted to, but what she actually did was something completely different. In the world of human rights advocacy for people with mental disabilities I discovered people who shared my experience, who gave me all their support, all their expertise, all their knowledge. And I tried to return that in kind. Solidarity, you know? This was the first time in my life when I experienced solidarity.

I remember that Edmund Hillary wrote in one of his books that when he was an adolescent he dreamed that as an adult he would be a very courageous person who would climb high mountains and discover undiscovered lands. And when he looked back at his life, he wrote that he never felt he succeeded, because every time he climbed onto a mountain, he was very much afraid. But what he learned is that even if you are afraid, even if you are not courageous, you can do things if they are important for you. In spite of the fear, you feel the presence of a peaceful entity. Even when I experience strong panic—which happens quite often—I do have some kind of spiritual peace. So, emotionally, I can be very threatened, very frightened, and even my soul can be confused, but still I feel that peace. It's not an abstract entity. But if I do not feel it, then it is a sign that I might do the wrong things. I remind myself that many of the mistakes in mental health care come from a helping attitude. But they want to help you without asking you, without understanding you, without involving you, "in your best interest."

I can understand those who are on the other side of this mental health care. I don't suppose that they are less valuable human beings. And by understanding, we can influence each other, at least on a personal level. And I really believe that change, social change, can happen only if it happens in various levels. If decision makers, as human beings, embrace human relationships with people with mental disabilities, and with other disabilities, this will advance change and understanding like nothing else.

227

MARINA PISKLAKOVA

RUSSIA

DOMESTIC VIOLENCE

"A woman called the hot line and said her husband planned to kill her. I called the police but the officer immediately called the husband, saying, 'Look, if you do it, do it quietly.' And I realized there was no hope."

Marina Pisklakova is Russia's leading women's rights activist. She studied aeronautical engineering in Moscow, and while conducting research at the Russian Academy of Sciences, was startled to discover family violence had reached epidemic proportions. Because of her efforts, Russian officials started tracking domestic abuse and estimate that, in a single year, close to fifteen thousand women were killed and fifty thousand were hospitalized, while only one-third to one-fifth of all battered women received medical assistance. With no legislation outlawing the abuse, there were no enforcement mechanisms, support groups, or protective agencies for victims. In July 1993, Pisklakova founded a hot line for women in distress, later expanding her work to establish the first women's crisis center in the country. She lobbied for legislation banning abuse, and worked with an openly hostile law enforcement establishment to bring aid to victims and prosecution to criminals. She began a media campaign to expose the violence against women and to educate women about their rights, and regularly appears on radio and television promoting respect for women's rights. Pisklakova's efforts have saved countless lives, at great risk to her own.

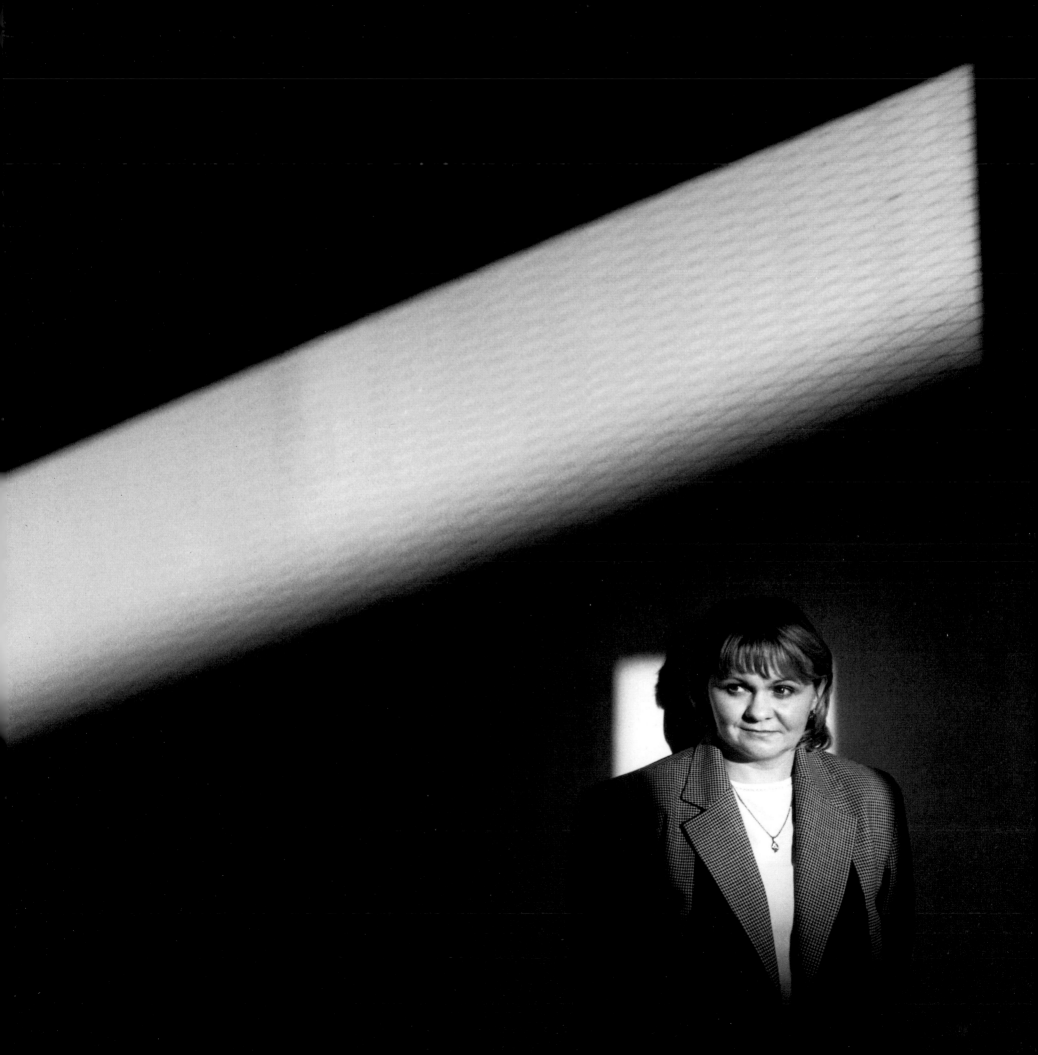

When I started the first domestic violence hot line in Russia in 1993 (we named it Anna, Association No to Violence), I was alone, answering calls four hours a day, every day, for six months. I was counseling people in person the other four hours. I couldn't say no; there were so many women. I had no training, no distance, no boundaries. But at the same time, I don't know how I could have done anything differently.

Without realizing what I was embarking upon, I began this work while a researcher at the Institute for Socio-Economic Studies of the Population within the Russian Academy of Sciences. While coordinating a national survey on women's issues, one day I received a survey response I did not know how to classify. It described a woman's pain and suffering at the hands of her husband. I showed it to some colleagues and one of them told me, "You have just read a case of domestic violence." I had never heard this term before. It was not something even recognized in our post-Soviet society, much less discussed. I decided I needed to learn more about this mysterious phenomenon.

Shortly thereafter, I encountered the mother of one of my son's classmates in front of the school. Half of her face was severely bruised. She wouldn't tell me what had happened. One evening a few days later, she called me. Her story shocked me. When her husband was wearing a suit and the button fell off, and it was not fixed quickly, he took a shoe and slapped his wife in the face. For two weeks she couldn't go out. She was really distressed, and hurt—physically and emotionally hurt—because half her face was black and blue. I asked her, "Why don't you just leave him?" A very typical question. And she said, "Where would I go?" I said, "Divorce him. Get another apartment." She said, "I depend on him completely." And in this exchange, I saw everything: the way the abuser was consolidating control, decreasing self-confidence, and diminishing self-esteem. I also heard her story of how he would come home and go to the kitchen, touch the floor with his finger, and, if there was the slightest dirt, ask sneeringly, "What did you do all day?" The floors in Russian kitchens always have some dirt, especially if you have kids at home who are running around—the kitchen is often the center of family life in our small apartments. For outsiders, scenes such as I have just described might seem ridiculous, but I was to soon discover that they were commonplace. For this woman, our conversation was an opportunity to communicate with someone who didn't judge her, who didn't say, "What did you do wrong?" I didn't realize that I had actually started counseling her. But I did realize from her story that from psychological violence comes physical violence.

So I started thinking that I should help her; I should refer her to somebody. And then I realized that there was nowhere to go. I cannot tell you my feelings. I really felt hopeless and helpless. In Russia there is a saying, "He beats you, that means he loves you." I now knew the meaning of that saying. I asked myself,

> "That's when the husband told her, 'I will kill you and nobody will know. And I will just say to everybody that you ran off with another man and left your baby.' I started calling her every morning just to make sure that she was alive."

"What can you do about a cultural attitude?" But I knew what I had to do. I started the hot line. One cold January day, a woman called in and I started talking with her. After a few minutes, she stopped, saying, "I am not going to talk to you on the phone. I need to see you." So I said, "Okay," and when she came in, her first tearful words were, "I'm afraid my husband is going to kill me and nobody will know." She told me her story. Her husband was very nice until she told him she was pregnant. At that point, everything turned upside down. He became very controlling. She was vulnerable and dependent: "I was terrified; his face was not happy. It was like he'd won. As though he was thinking, 'It's my turn. Now I can do whatever I want to you.'" The danger was real.

My first reaction was, "Oh, my God, what am I going to do now?" I knew the police would do nothing. But I called the police in her district anyway. The officer seemed nice, but then he immediately called the husband and said to him, "What is your wife doing? And why is she going around talking about family matters? Look, if you do it, do it quietly." I realized how hopeless the problem really was for her. Her problem became mine. I could not walk away. I called a woman I knew who was a retired lawyer and said, "I don't have any money and this woman doesn't have any money. But she needs help. She needs a divorce and a place to live." In Moscow, housing is a big problem. When this woman married her husband, she traded her apartment to his family and now his brother lived there. So she had nowhere to go. She was

trapped. Her story got worse. When their first baby was nine months old, her husband tried to kill her. "I don't know how I survived," she told me. The lawyer and I helped her file for divorce. That's when the husband told her, "I will kill you and nobody will know. And I will just say to everybody that you ran off with another man and left your baby." I started calling her every morning just to make sure that she was alive. For three months, the lawyer counseled us at each stage and helped us develop a plan.

In the midst of all of this, the situation took a scary turn. The woman called and said: "They know everything we are talking about!" Her mother-in-law worked at the phone company and we quickly figured out that she was listening to her calls. I said, "You know, maybe it's better. Let them hear about all the support that you have outside." So we started pretending we had done more than we actually had. On the next phone call, I started saying, "Okay, so this police officer is not helpful, but there are lots of other police I am going to talk to about it and your lawyer will, too. So don't worry." The next time she came to see me, and she said, "They became much more careful after we started talking that way." Eventually her husband left their apartment, partly because the lawyer told us how to get him out, and partly because he and his family realized that she was educated about her rights now. Ultimately, they got a divorce. Her father-in-law came to see her and said, "You have won, take the divorce, and take back the apartment; you will never see my son again."

Soon after this success, a friend of hers in a similar situation started legal proceedings against her own ex-husband and also got her apartment back. I was elated, and for the first time, encouraged! Even in Russian society, where there were few legal precedents, a woman who is willing to do so can stand up for her rights and win. But these stories are just a small fraction of the thousands we continue to hear day after day. Unfortunately, most of the women who call us do not know their rights, nor do they know that they do not have to accept the unacceptable.

There have been some bad moments along the way. One time I picked up the phone and a male voice started saying, "What is this number?" I was cautious since it was not common for a man to call our hot line like that. I responded with "Well, what number did you dial?" And he said, "I found this phone number in the notes of my wife and I am just checking—what is it?" I told him, "Why don't you ask your wife? Why are you calling?" And at first he tried to be calm and polite, saying, "Look, I'd just like you to tell me what it is." And I said, "If you don't trust your wife, it's your problem. I am not going to tell you what it is and I am not asking your name. If you introduce yourself maybe we can talk." And then he started being really aggressive and verbally abusive and he said, "I know who you are. I know your name. I know where you are located. I know where you live. And I am going to come there with some guys and kill you." My husband was there with me at the time and saw I was really scared, though

I said to the man on the phone, "I am not afraid of you," and just hung up. I still don't know whose husband it was. He never came. Another time, my phone at home rang late at night and a man said, "If you don't stop, you'd better watch out for your son." This really scared me. I moved my son to my parents' home for a few months. That was tough for a mother to do.

There are different estimations of domestic violence in Russia. Some say now that 30 to 40 percent of families have experienced it. In 1995, in the aftermath of the Beijing Women's Conference, the first reliable statistics were published in Russia indicating that 14,500 women a year had been killed by their husbands. But even today, the police do not keep such statistics, yet their official estimates are that perhaps 12,000 women per year are killed in Russia from domestic violence. Some recognition of the dimensions of this problem is finally surfacing.

Under Russian law, however, only domestic violence that results either in injuries causing the person to be out of work for at least two years, or in murder, can be considered a crime. There are no other laws addressing domestic violence in spite of years of effort to have such laws enacted by the Duma. But, in my work and in our fledgling women's movement, we have on our own expanded the functional definition of domestic violence to include marital rape, sexual violence in the marriage or partnership, psychological violence, isola-

"The attitude during Soviet times was that if you are a battered wife, then you had failed as a woman and as a wife. It was the woman's responsibility in our society to create a family atmosphere. Women came to me who had been brutalized for twenty-six years."

tion, and economic control. This latter area has become perhaps one of the most insidious and hidden forms of domestic violence because women comprise 60 percent of the unemployed population—and the salary of a woman is about 60 percent of a man's for the same work.

A friend started working with me in January 1994, and by that summer we had trained our first group of women who began to work with us as telephone counselors. In 1995, I started going to other cities in Russia putting on training sessions for other women's groups that were starting to emerge and who wanted to start hot lines or crisis centers. Next, we started developing programs to provide psychological and legal counseling for the victims of domestic violence.

By 1997, we had also started a new program to train lawyers in how to handle domestic abuse cases. Under present Russian law, the provocation of violence is a defense which can be argued in court to decrease punishment. This is perhaps the most cruel form of psychological abuse, because it all happens in the courtroom right in front of the victim. She is made to look responsible. The victim is blamed openly by the perpetrator. Regrettably, there are still many judges who will readily accept the notion that she was in some way responsible, and let the perpetrator avoid being held accountable for his actions. The final trauma has been inflicted.

At the start of the new millennium, we have over forty women's crisis centers operating throughout Russia and have recently formed the Russian Association of Women's Crisis Centers, which is officially registered with and recognized by the Russian government. I am honored to have been elected as its first president.

My parents have been incredibly supportive of my work. My father, a retired military officer, once said to me, "In Soviet times you would have been a dissident, right?" And my reply to him was, "Probably, because the Soviets maintained the myth of the ideal—where domestic violence couldn't exist, officially." The attitude during Soviet times was that if you are a battered wife, then you had failed as a woman and as a wife. It was the woman's responsibility in our society to create a family atmosphere. It was up to her to maintain the ideal. That's why women came to me who had been brutalized for twenty-six years. I was the first person they could turn to openly, and confide something they had to hide within themselves throughout their life. This is still true to a great extent today.

I am not an extraordinary person. Any woman in my position would do the same. I feel, however, that I am really lucky because I was at the beginning of something new, a great development in Russia, a new attitude. Now, everybody is talking about domestic violence. And many are doing something about it.

ASMA JAHANGIR AND HINA JILANI

PAKISTAN

HUMAN RIGHTS STRATEGIES

"You are fighting with your pen, you are fighting with the instruments of law, against a power with a gun, a power that does not recognize the law."

For the past two decades Asma and her sister Hina have been at the forefront of both Pakistan's women's and human rights movements. Both have been subjected to twenty-four-hour-a-day surveillance by the state since 1996. In 1980 they helped found the Women's Action Forum to help women obtain divorces from abusive husbands. In 1981 they founded the first all-women's law firm in Pakistan, and in 1986 they founded the Pakistan Human Rights Commission, where Jilani serves as chair. Threatened with death from the very halls of parliament when she called for the abolition of repressive shari'a laws contravening constitutional protection of women, Jahangir also put her life on the line in 1993 when she represented an illiterate fourteen-year-old sentenced to death for blasphemous graffiti on the side of a mosque. Muslim extremists stormed the court-house, smashing Jahangir's car and attacking her driver. A gang of armed thugs subse-quently raided Jahangir's brother's home, holding her family hostage. In 1998 the United Nations Commission on Human Rights appointed Jahangir special rapporteur on extra-judicial, arbitrary, and summary executions. Hina Jilani runs the largest free legal aid cen-ter in Pakistan and is known for her defense of women's and children's rights, and for her efforts to promote religious tolerance. On April 6, 1999, Samia Imran, one of Jilani's clients, who sought divorce after a four-year separation from her husband, was in the offices of the law firm for a meeting with her mother and uncle. They arrived accompa-nied by a former chauffeur who drew a gun, shot and killed Imran, and almost killed Jilani. Imran's family considered the divorce a shame on their family that justified this "honor killing." Imran's father, the chair of the Peshawar Chamber of Commerce, awaited news

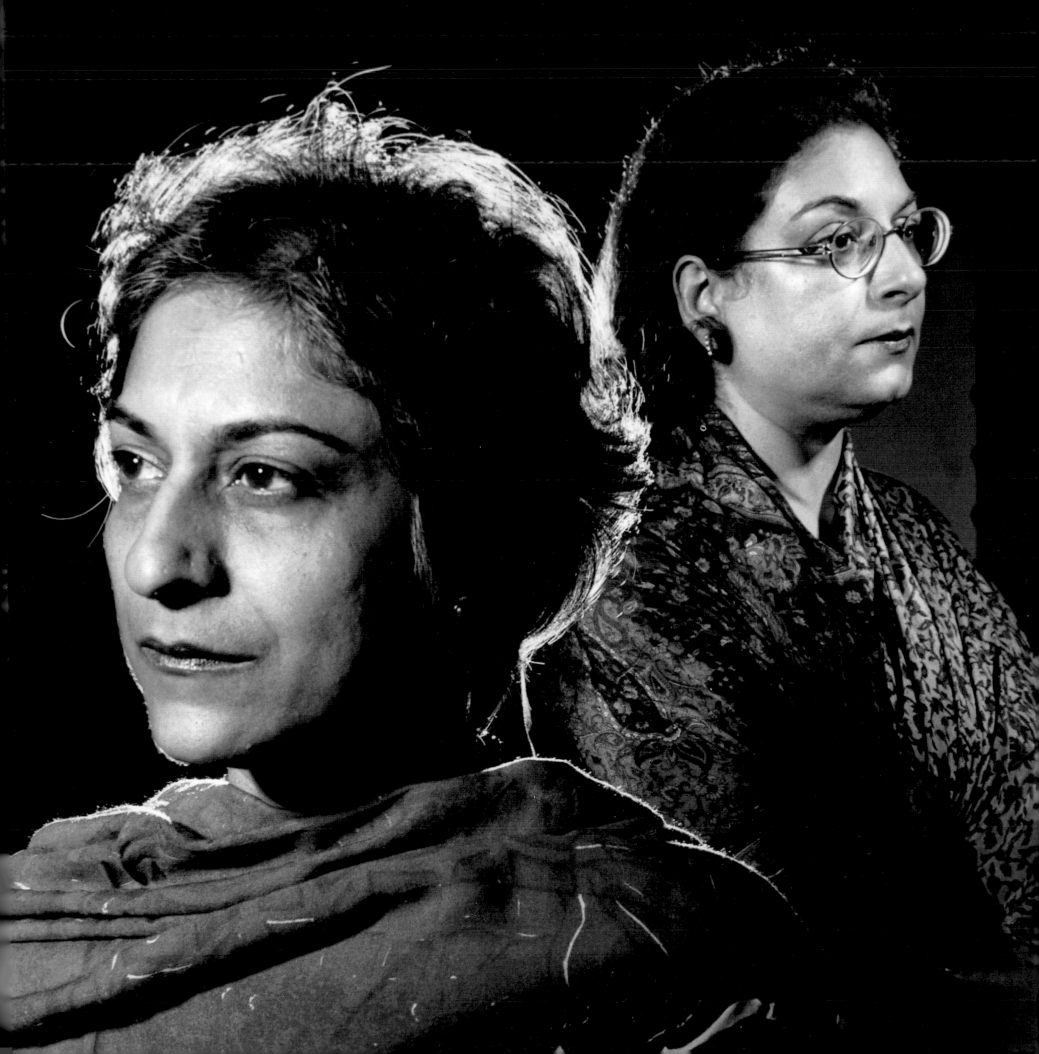

of his daughter's death at a nearby hotel. The father subsequently filed kidnapping charges against Jilani and Jahangir. Five hundred women were murdered in honor killings in Pakistan in 1998 and Jilani is known throughout the world for her outspoken criticism of the practice. Sisters in blood and in spirit, they are an inspiration to all.

JILANI Activism is vital for those who wish to fight for human rights. A human rights defender at the desk is only a reporter. A human rights defender in the field is a foot soldier. We are the ones who will make a difference. Exposing realities is not easy. If people get the message that only extraordinary people do this work, then the movement becomes static and discourages others from joining. That's why I am always keen to stress we are just ordinary people who have made up our minds that we have a cause we are fighting for.

My sister Asma and I grew up in an environment in which human rights were always talked about. My father was a politician who stood for basic freedoms. He took chances with his political career rather than compromise on fundamental rights. He was also one of the very few people who consistently spoke out for religious tolerance and urged expression of dissenting views.

Asma and I began working as lawyers in Pakistan in the 1980s, fighting martial law. We were dealing with victims of the regime all the time. That experience drew us into the human rights movement. We were able to give impetus to the movement through our work. The law became a tool in our hands that we used in court—though you must understand that there is a limit to what you can do with law in a country like Pakistan, where the rule of law doesn't enjoy respect. Law has become an instrument of repression, rather than an instrument for change. So human rights involves work both at the legal and at the social level. In fact, you can't work on human rights in an isolated way—you have to respond and react to the environment in which you live. Under the early days of military rule the strategy was to go out into the streets and make ourselves visible, because the courts were terrible at that time. And though many people were afraid to come out into the streets, those who did joined our movement.

JAHANGIR The priorities have always been that human rights and political development are connected—you can't say you want human rights only for a specific issue. Rights for children, rights for bonded labor, rights for women, they are all part of our struggle. They are all compromised by the system we are fighting, a system that doesn't recognize rights. In 1968, the first time I actually organized a demonstration of women, I had just finished school—I was sixteen. Martial law was accepted all over, and people actually associated martial law with economic development and stability. But even as a young girl, I was conscious of the fact that you cannot expect democratic economic development if it does not allow the participation of all people.

"A human rights defender at the desk is only a reporter. A human rights defender in the field is a foot soldier. We are the ones who will make a difference."

Using the court system was nothing new to us. Our father was placed in preventive detention many times for his opinions and he defended himself each time. Once he challenged the law that stopped courts from reviewing preventive detention cases. He argued there had to be an objective reason, not an arbitrary one, for the detention. He put the responsibility squarely on the judicial system, saying, "Who will see the objectivity if the courts are not there to look at it?" And he won, and that tool of government repression fell from their hands.

During the war between East and West Pakistan, he was very vocal about the rights of East Pakistanis. As a result, we went through a very difficult year. I was called a traitor's daughter many times. I went out one day with some older women who had asked me to come because they had these little pamphlets to distribute that spoke of the rights of East Pakistanis. About seven of us were standing on the roadside and because I was the youngest, they said, "Why don't you just give the brochure to people as they stop in their cars?" And this one man, while I handed it to him through the window, he rolled down his window and spat on my face. So one has seen that kind of intolerance.

When our father was in jail, I was a student and I just turned eighteen. I organized a petition for him that actually challenged military governance. It was the only case in Pakistan that said that a military government is an illegal government. It was amazing that we could do it. Actually, when you are doing something like

that you are not only getting to know what your principal stands are going to be in life, but you also get to know your society, and how it works, and with that knowledge you determine your strategies.

We've been fighting honor killings for many, many years. It doesn't automatically become an international issue—you have to really keep the flag raised, to work the media as well as the courts. It's very important for a human rights activist to be media-friendly. They want news. And so whatever you do, there has to be news in it; even though you are giving them new statistics, are you giving them a new face? Are you giving them a new story? A new story makes new news. It was through the media that honor killings became a front-burner, international issue.

When I became (United Nations) special rapporteur on extrajudicial killings, it was the first issue that I put into my mandate. And now the special rapporteur on independence of the judiciary has also taken it up. Here is an example. One day a client of ours seeking divorce was shot, murdered, at our office by a gunman hired by her father (who felt his daughter's divorce would bring shame upon their family). Public opinion was already leaning toward us. People had seen films about the issue and were aware of it and the press was aware. And the fact that the government resisted condemning this murder—because the bias of the government was so clear—and worse, that the parliament then resisted it, actually made news for us.

But it got worse. The chamber of commerce put forth a resolution implicating us in the murder! This was reported in the newspapers and there was a demonstration organized against us and open threats. The government stood by as a silent spectator. In fact they helped the murderers, who were never, ever touched. First, the government filed an information report to the police against Hina and me in another city saying that we had murdered that girl. Second, they told the entire administration not to arrest the murderers. Arrest warrants were not even issued until after they managed to get bail, many days after the murder had taken place. We are still in court about it. And now the real murderers have been declared innocent by the police.

So you see that, in this kind of work, you're fighting in a complex situation. You are fighting with your pen, you are fighting with the instruments of law, against a power with a gun, a power that does not recognize the law and has an insidious influence with the government. So the most important thing is, it cannot be an individual fight. The formation of the Pakistan Human Rights Commission in 1986 helped focus our work, gave it structure. Today I can stand up in Pakistan and say, "This is wrong." I can do it because I know that colleagues are there who think like me and we will all work together. It is important that we give each other strength. We draw on each other's strong points. Let me give you an example. We are lawyers, so if there is a case anywhere they will send it to us. But our Human Rights Commission annual report is written by two other colleagues (and I don't think anyone can write better than they) who are using their expertise in this way. A third colleague is very good at media, communications, at getting the word out. So you get to the front line not because you are actually the person doing the important work, but because you have distributed the work and somehow you evolve as a person who has been chosen for the front line by the whole movement. That's how I feel about myself. Teamwork is absolutely crucial and essential. And recognition has to be given to all the people out there who made this movement—together.

JAHANGIR As a sister, I work with Hina in the office. But on many of my other issues we really don't work together. I do my own thing.

JILANI Sibling rivalry is always there. But the point is, though we may be sisters, that is just incidental. We are both independent. Neither of us is inspired by the other alone; instead we are inspired by our surroundings. I am a very laid-back person, but one thing I can't tolerate is injustice. That makes that adrenaline run, which makes me get up and take action.

JAHANGIR Leadership involves the ability to conceptualize goals, share responsibilities, and set things in motion. Yet the only way that we survive is to have people who are working together and draw strength, draw confidence from each other. None of us is fool enough not to realize what the risks are; nevertheless, we try to mitigate them whenever we can. We are ordinary enough to feel fear at times. We are ordinary enough to feel the pressure. But we just go on.

JILANI I deal with fear by looking around me and saying we'll survive and we'll do this again. It's like one more bridge. I look around and see that others have overcome that fear. It's not that I am not frightened. I am. Not just for myself,

"None of us is fool enough not to realize what the risks are; nevertheless, we try to mitigate them whenever we can. We are ordinary enough to feel fear at times. But we just go on."

but for Asma at times, at a very personal level. I don't have children, but Asma has. And I have brothers and sisters and a mother. And they have been attacked. It's difficult to say how we deal with it. The guilt is there. It happens. And the concern is there—even greater than guilt.

JAHANGIR I honestly tell you, I have been able to overcome fear. It was not easy. But every time I felt frightened I would go to the home of the Human Rights Commission's director. I would invite all our friends there and we would have a good laugh. A sense of humor and the warmth of the people around has made me survive. If I were sitting by myself, isolated, I would have gone crazy. But the minute I see a half-dozen of my colleagues, well, it's a jolly day—I don't feel scared at all. Of course, our families have to pay the price for our commitment, I feel no guilt about it at all. I have thought about it very carefully. I think that if I die tomorrow my children will be well looked after. They have a very good father. They have three grandparents who are still alive. They have an aunt who is not married. They are nearly grown, my children: 23, 21, and 17. So in terms of building their values (which is what I was most interested in as their mother), they've got that. They have to learn to live in a society that is very brutal and very violent. There is no guarantee for anything, and I think my children understand that now, appreciate it. They are very worried for me. I have had to sit them down, and explain to them, and even sometimes joke with them and say, "Okay, now what I am going to do is get myself insurance, so when I die you will be rich kids." They have gone through psychological trauma but they have dealt with it. It has made them stronger people.

Once seven armed people came into my mother's house (where Hina lives), looking to kill me and my children. And they took my brother, my sister-in-law, my sister, and their kids as hostages. Hina had fortunately just left the house in the morning with my mother. We always joke with her that it was one hour to mincemeat. But it was really very scary. That was one time that I was really upset about my family, extremely upset.

And I appreciate very much that my brother and sister, especially, because they are not human rights activists, have never said, "Give up." Never, ever have they said that this danger they experienced was because of me. That has been such a source of strength for me. They make me feel so proud. How can they be so decent about it? How can they be so understanding? It makes me more brave that there are people like them in this world.

The danger is real. Sometimes I have to tell my colleagues in the Human Rights Commission, "Take a back seat." We have a very good understanding on this, because I am already in danger, whether we stop or don't. So why put another person in danger?

JILANI I never feel a sense of futility—ever—because I think what we do is worth doing. In the years that we have been working, the small successes count for a lot. They may be few and far between but the point is they are significant. We feel that something is there, a light at the end of the tunnel. And we have seen that light many times.

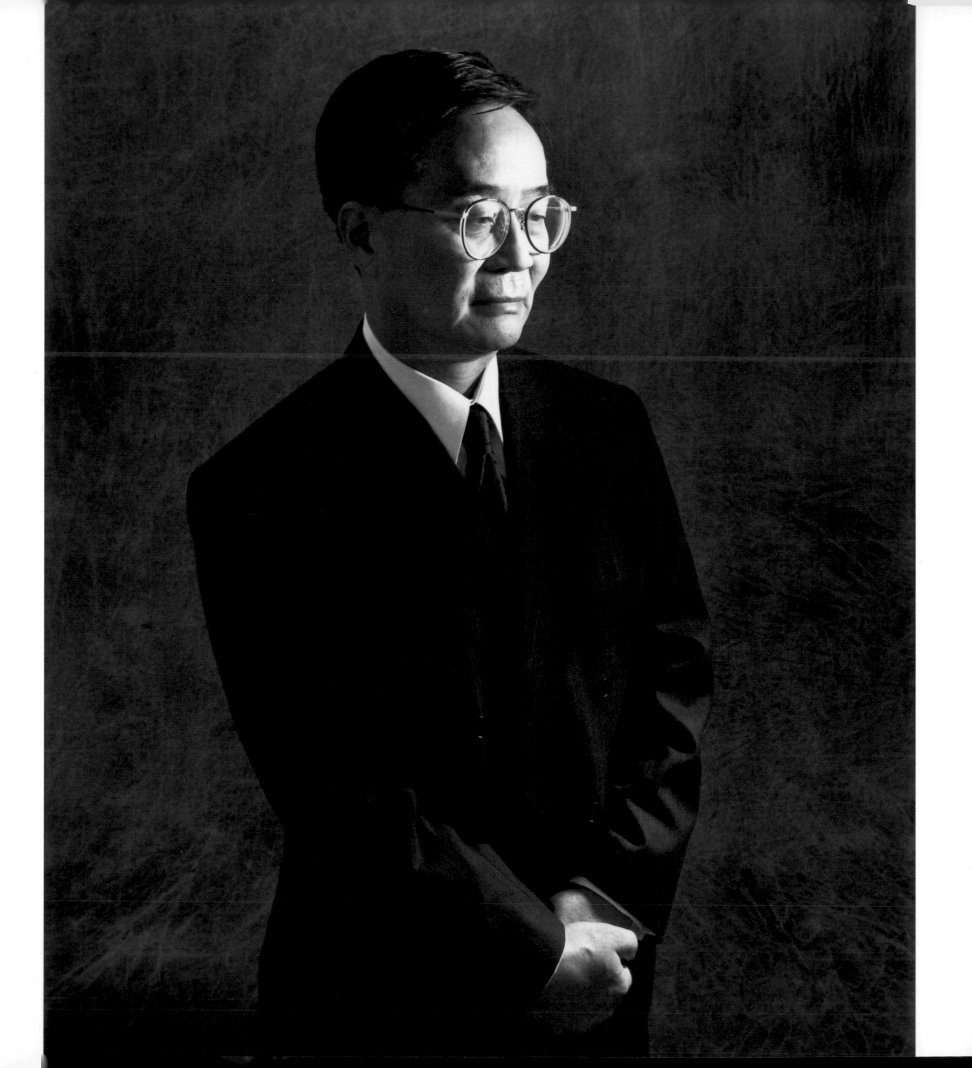

HARRY WU

———

THE *LAOGAI*

"It is not enough to free one dissident when the stakes
are so high. In the greater balance, we are all equal, and each
victim of the *laogai* deserves the same rights."

Brought up as one of eight children of a Shanghai banker, Harry Wu attended a Jesuit school before enrolling in Beijing College of Geology in the late 1950s. In the throes of a Communist purge, his university was given a quota of counterrevolutionary elements, and relegated Wu to nineteen years in the Chinese gulag, known as the laogai. *There, he survived physical and psychological torture, living for a time on only ground-up corn husks. In his autobiography* Bitter Winds, *he describes chasing rats through the fields in order to "steal" the grains in their nests, or eating snakes. After his release, Wu accepted a position as an unpaid visiting scholar at the University of California, Berkeley, arriving in the United States in 1985 with forty dollars. After ten days of pursuing research by day and sleeping on a park bench by night, he landed a job on the graveyard shift at a doughnut shop where he ate three meals a day and had a place to stay at night. (To date, he cannot touch a doughnut.) Wu returned, or tried to return, to China a total of five times. While there, twice in 1991 and once in 1994, Wu documented conditions in prisons and labor camps for* Sixty Minutes, *and other news programs, and was placed on China's most wanted list for his exposés. In 1995, on his fifth trip, he was caught. While Wu spent sixty-six days in detention, awaiting news of his fate, a worldwide campaign for his release was launched, including demands that Hillary Clinton boycott the Beijing women's summit. China released him, and his return to U.S. soil was celebrated across the country. Today, Wu frequently testifies on Capitol Hill about the latest abuses he has uncovered—the for-profit selling of executed prisoners' organs by Chinese officials, the illegal export of prison labor products (such as*

diesel engines and Chicago Bulls apparel), the frequency of public executions, the unfair restrictions on reproductive rights and their appalling enforcement procedures. The Laogai *Research Foundation, which Wu founded and directs, estimates there have been fifty million people incarcerated in the laogai since 1950, and that there are eight million people in forced labor today. Harry Wu's self-proclaimed goal is to put the word* laogai *in every dictionary in the world, and to that end, works eighteen-hour days crisscrossing the country and the globe speaking with student groups and heads of state to make this present-day horror become a past memory.*

Human beings want to live as human beings, not as beasts of burden, not as tools for another's use. People must respect each other enough to live with one another but retain the right to free choice: to choose their religion, their culture. Under totalitarian regimes, people are never treated as human beings. There is no free choice. If you talk about individual rights, you are automatically opposing the government.

Many American politicians and American scholars echo the Chinese lie that a different concept of human rights applies in China. The Chinese leadership argues that the most important category of human rights is economic rights. Jiang Zemin, president of China, said, "My first responsibility to human rights is feeding the people." In response, I would say that I can feed myself if I am

free—I don't need you to do that. Unfortunately, some Westerners say, "The Chinese never talk about individual values, they talk about collective rights, so don't impose Western human rights standards on the Chinese. Democracy is a Western idea." This is pure hypocrisy, because there is only one version of the Universal Declaration of Human Rights, of which China is a signatory. We don't have a Chinese version and an American version. It's universal.

The West mostly focuses on freedom of speech and freedom of religion, while trying to release religious dissidents, political dissidents, and student dissidents. So most of the West's focus is on the individual, this Catholic father, that Tibetan monk. On the one hand, it is very important to call for their freedom because life belongs to a person only once, never twice. We must save them. But we Chinese say "Never focus on only one individual tree; focus on a forest."

Let me tell you a story of the three W's: Wu, Wei, Wang Dan. I am the first "W." In 1957, while attending university in Beijing, I spoke out against the Soviet Union's invasion of Hungary. For this I was labeled a "counterrevolutionary" and sentenced to life in the *laogai*, the Chinese term for gulag. Ultimately, I gave nineteen years of my life to that system. In 1979, the year I was released, the West was applauding China for opening up. Mao was dead, the Cultural Revolution was over, and it seemed that Deng Xiaoping would herald a new era for China. But that same year, the second "W," Wei Jingsheng, was imprisoned for expressing himself, for calling for the fifth modernization of democracy for China. In 1989, when I was in the United States and Wei was

serving the tenth year of his sentence, another young man, Wang Dan, was imprisoned for his role in the student democracy movement. The Chinese government imprisoned each of us in three different decades for peacefully expressing our opinions; we all received second sentences in the 1990s. With respect to individual rights, not much has changed since 1957.

The first year of my first time in prison, I cried almost every day. I missed my family, especially my mother, who had committed suicide because I was arrested. I thought of my girlfriend. I was Catholic, so I prayed. But after two years, there were no more tears. I never cried, because I had become a beast. Not because I was a hero, not because I had an iron will, but because I had to submit. I don't think anyone under those circumstances could resist. From the first night in the camps, we were forced to confess. The confession destroys your dignity. If you don't come up with a confession, you are subjected to physical torture. And you have to keep your confession straight, all the time, from the beginning to the end. You never can claim you are innocent. You can only cry out, over and over, "I am wrong. I am stupid. I am crazy. I am shit. I am a criminal. I am nothing." At the same time, there is forced labor. Labor is one of the ways to help you become a new socialist. Labor is an opportunity offered by the party for your reform. The final goal is for you to turn into a new citizen in the Communist system.

They said my crime was light, not serious, light. But my political attitude was the problem. "I did nothing wrong," I said. "You trapped me. I am not going to admit to any crime." I wouldn't confess. They separated me from all the

people in my life, my classmates, my friends, my teachers, my parents. I was totally isolated. I thought, "I am a mistake. They don't like me. I am something wrong. Let me think about it, okay." And then, "Yeah, I am wrong." Step by step, I lost my dignity, lost my confidence, lost my rank. I started to believe I was a criminal. It was as if we Chinese were living in a box all our lives where we never saw the sky. If you never escape from the box, you come to believe that it is the truth. That is reprogramming, which in the end reduces you to a robot. One drop of water can reflect the whole world, but many, many drops become a river, an ocean.

Nineteen years. How many days, how many nights? I punched someone in the nose and stole from people. I never cried. I stopped thinking about my mother, my girlfriend, my future. Some people died. So what? They broke my back. I had human blood on my lips. I had forgotten so much.

In 1986, I first came to the United States as a visiting scholar. I remember the day in October of that year when I gave a talk on the *laogai*. I told myself, "You are not Harry Wu. You are a storyteller." Suddenly I could not stop. For twenty minutes, the students were very quiet. I finished my talk and I realized I had come back as a human being. The end of that talk was the first time I said, "I am so lucky I survived."

When I first came to America, nobody knew me. Just like in the camps, I was anonymous. The Chinese government put me on the wanted list because I touched the heart of the issue. If you want to talk about dissidents, the Chinese

are willing to speak with you, but not if you talk about the *laogai*. Can you talk to Hitler about concentration camps? Can you talk to Stalin about the gulags?

I don't know why I survived. You think of yourself as a human being, fighting for your dignity, fighting for your future, fighting for your life, fighting for your dream. Life will only belong to you once. Sooner or later you and I are going to go to the grave. Some people take thirty years, eighty years. Once I was in exile, why shouldn't I have enjoyed the rest of my life? Why did I need to go back to China? I tried to enjoy it. I felt guilty. Especially when people were calling Harry Wu a hero. The West is pushing me because it is always in search of a hero. But a real hero would be dead, dead. If I were a real hero like those people I met in the camps, I would have committed suicide. I am finished—there is no Harry Wu. That is why I ultimately decided to go back to China.

In 1991, I visited the *laogai* camp where Wei Jingsheng was held in China. He was in the Gobi Desert and I wanted to get some video footage to show people the situation. In the past, I posed as a prisoner, a tourist, or a family member. This time I posed as a policeman. They didn't recognize me. In a guesthouse, many policemen waved to me, and I waved back to them. But when I tried again to collect evidence in 1995, they caught me trying to enter China from the Russian border. They arrested me and showed me these pictures I had taken. This time, I was sentenced to fifteen years.

Now I am working on birth control issues, because this is another systemic human rights problem in China. Without government permission, you can't

have a child in China. I have a copy of the "birth-allowed" permit and the "birth-not-allowed" permit from the Fujian province. After one baby, you are supposed to be sterilized. If you are found to be pregnant a second time, the government forces you to abort. You cannot have a second child, unless you live in the countryside. In this case, you can wait four years and then have a second baby. Then, after that baby's delivery, you are forcibly sterilized.

An American sinologist told me the population growth in China is terrible, causing problems not only for the Chinese, but the whole world. And I said, "Do you agree to forced abortion in the United States?" He replied no. "But why are you applying that standard to the Chinese?" I responded. "It's a murder policy. It's a policy against every individual woman, against every individual." Government statistics tell us that in one area of China alone, 75 percent of the women between the ages of sixteen and forty-nine have been sterilized—1.2 million people. Every month there are about one hundred abortions.

Today, the Chinese people do have the right to choose different brands of shampoo but they still cannot say what they really want to say. Will the right to choose one's shampoo lead to the right to choose one's religion, as some would argue? It's quite a leap.

My choice was simple—imprisonment or exile. But what people don't understand is that exile itself is torture. Exile, too, is a violation of human rights. We never applauded the Soviets when they exiled dissidents. Yet, when the Chinese exiled Wang Dan, the State Department and the White House claimed it as a victory for United States engagement policy.

Of course, I do think it's worthwhile to try to free someone from the machine, but I would rather see the machine destroyed. I come from the *laogai*. Wei Jingsheng came from the *laogai*. Now Wang Xiaopo is in the *laogai*. Catholic priests are in the *laogai*. Labor activists are in the *laogai*. Most of the people in the *laogai* don't have a name, they don't have a face. It is not enough to free one dissident when the stakes are so high. In the greater balance, we are all equal, and each one of the victims of the *laogai* deserves the same rights, not only the political dissidents, but even the criminal prisoners. This is not to say that we should excuse the crime, but each prisoner must be offered the same protection. You tend to forget that when you only talk about famous prisoners of conscience. It's hard to say what percentage of prisoners are political compared to those that are criminal. You can present the question to Chinese authorities and they answer that in China there are no political prisoners. They will say, for instance, that it is legal to practice your own religion, but if you practice Catholicism they arrest you and charge you with disturbing society and participating in an illegal gathering instead.

Every totalitarian regime needs a suppression system. The funny thing is that nobody talks about that system in Communist China. They say that it doesn't exist, or that they only use it in the case of particular individuals. I've given talks about the *laogai* at all the top universities in the United States. When I was at

> "I want people to be aware of
> how many are in prison.
> Aware of the products made in China
> by prison labor: the toys, the footballs,
> the surgical gloves. Aware of what
> life is like under forced labor.
> This is a human rights issue, not one
> of imports and exports."

Yale, I spoke to Jonathan Spence, who wrote the most widely used college text on China. I said to him, "Jonathan, you speak Chinese very well, you have a Chinese wife, you include so many Chinese terms in your work. But what about *laogai*? The victims of the *laogai* number more than those of the Soviet gulag plus the concentration camps. Of course, you've heard of it, but it never appears in your reports, your articles, your books. You don't want to talk about it—why?" Why doesn't Steven Spielberg film the *laogai* the way he did the concentration camps?

I want to see *laogai* become a word in every dictionary, in every language. *Lao* means "labor," *gai* means "reform." They reform you. Hitler, from the beginning, had an evil idea: destroy the Jews, destroy the people. The Communists in the beginning had a wonderful idea to create a paradise, a heaven, to relieve poverty and misery. In the beginning they were like angels, but at the end they were like devils. The Chinese perpetrate a lot of physical torture, but also spiritual torture and mental torture. They say, "Let us help you to become a new socialist person. We won't kill you, because of our humanity. You were going wrong. Confess. Accept Communism and you will, through reform, reestablish the community spiritually, mentally, totally."

Before 1974, *gulag* was not a word. Today it is. So now we have to expose the word *laogai*: how many victims are there, what are the conditions the prisoners endure, what is the motivation for such systematized degradation? I want people to be aware. Aware of how many men and women are in prison. Aware of the

products made in China by prison labor: the toys, the footballs, the surgical gloves. Aware of what life is like under forced labor. Aware of the so-called crimes that send people there. This is a human rights issue, not one of imports and exports.

I totally understand this is difficult talking about *laogai* today. I said to President Clinton, "I wish you would be the first world leader to condemn Chinese *laogai*. I beg you. Just one sentence. It won't cost you anything." And I criticize U.S. policy as a typical appeasement policy. U.S. leaders ask me, "Are you suggesting isolation or containment?" That kind of polarization is too cheap. I never suggest isolation and I never suggest sanctions. But you should not tell me a one-sided story. When you try to tell me that trade is improving the lives of the Chinese common people, this is only one side of the story. I don't argue that economic levels are improving, that a middle class will appear, property rights will come to the fore, and that the society will reorganize. But you have to tell me the other side of the story. The profits from the industry will only benefit the Communist regime. You don't talk about it. The Chinese Communist regime is stable. Why? Because you support it financially.

China will become more important in the near future. When we witness a Communist hegemony in the East, then we will debate why. Why did we ignore the growing strength of this authoritarian regime? Let me quote another Chinese idiom: "If you want to stop the boiled water, you only need to stir it. The better way is to withdraw the fire from the bottom." The West needs a long-term China policy, one that supports all of the desires for freedom and democracy in China.

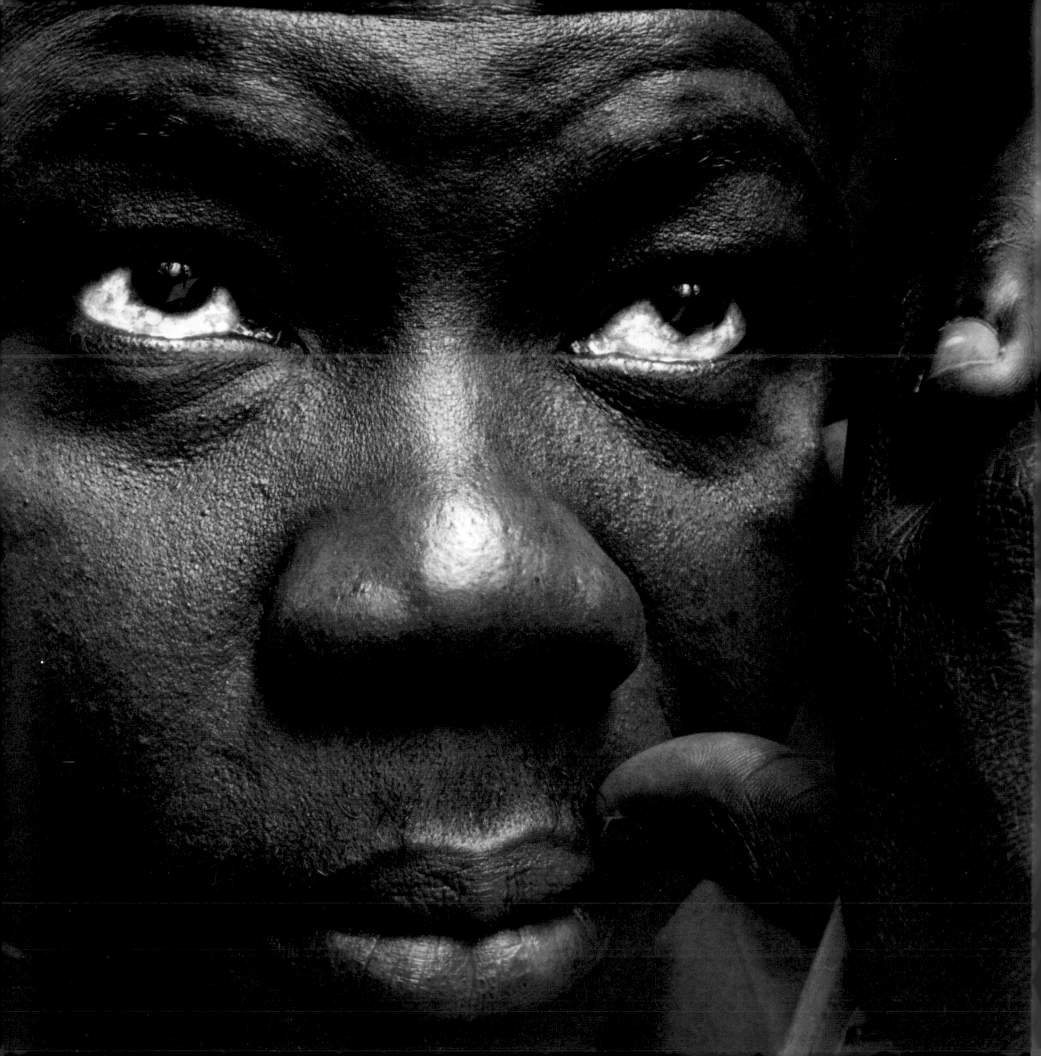

FREEDOM NERUDA

IVORY COAST

FREE EXPRESSION

"After soldiers beat and killed university students, fifty thousand people demonstrated to demand an investigation. Human rights leaders were arrested and thrown in jail for months. I couldn't stand the official lies. I decided to expose the courtroom drama."

Journalism has become one of the world's most dangerous professions, with dozens of deaths and hundreds imprisoned because of their exercise of free speech. Freedom Neruda exemplifies the extraordinary courage of these engaged journalists who report the news despite severe restrictions by the state. Born Teiti Roch D'Assomption in the Ivory Coast in 1956, he chose the name Freedom Neruda to symbolize his ideals. Neruda graduated from the University of Abidjan and taught until 1988, when he began working as a copy editor at Ivoir Soir. Within two years Neruda had become an investigative reporter, working for Ivoir Soir, La Chronique du Soir, and La Voie. As the current chief editor of La Voie, Neruda has consistently covered the repressive government first of President Henri Konan Bédié and, after his overthrow, on December 24, 1999, that of General Robert Guei—despite the government's relentless attacks on Neruda and his staff, subjecting them to arbitrary fines, charges of "insulting the dignity of the head of state," assaults, arrests, threats, and harassment. In 1995, Neruda's office was firebombed. In December 1995, after Neruda published a satirical article blaming the national soccer team's loss to South Africa on "bad luck" occasioned by President Bédié's presence at the game (a reference to Bédié's electoral posters claimed he'd bring "Good Luck" to the country), Neruda's colleagues at Ivoir Soir were arrested, and he went underground. In 1996, Neruda was apprehended and sentenced to two years in prison for "offenses against the head of the state." All three journalists refused to accept a "pardon" (tantamount to admitting guilt) from Bédié; instead they took advantage of their experience to conduct an investigation, while behind bars, on prison conditions. Neruda was released from prison in 1997 and continues to speak out, speak up, and speak "truth to power."

When political pressures relaxed in the Ivory Coast, people had the right to create their own parties. Workers were allowed to organize trade unions. And there was the opportunity of creating several newspapers. Along with two friends, I created my own: *La Chronique du Soir*. It was difficult because we had little funding and, as ours was the first independent paper, the government didn't condone our existence. We had problems; distribution was one of them. My paper would arrive at the distributor's office at nine, but it would never appear on the market before three.

After soldiers killed students and beat others at the public university, fifty thousand people demonstrated to demand an investigation. That was February 12, 1992. Human rights leaders were arrested and thrown in jail for months. The press accounts of the trials were one-sided. I was at the demonstrations and saw what happened with my own eyes. So when I watched TV later, I couldn't stand the official lies. I decided to expose the courtroom drama. Thanks to our efforts, several months later the demonstrators were freed. That is why I decided to work in our country for democracy, freedom of press, freedom of expression, and freedom of speech.

These events marked a turning point for our country. In 1960 the Ivory Coast gained independence from France, and for the next thirty years we were ruled by a single party. In 1991 the government passed a censorship law where almost everything was forbidden. Under this law journalists in the Ivory Coast have many duties and obligations—and almost no rights. And if you read these laws and you want to become a journalist you really should go grind peanuts because it is better for you.

Bédié became president in December 1993, and by February 1994 we started writing that he was implicated in a corruption scandal involving the sugar industry. A few months later, we were sentenced to one year on criminal libel charges. They said that any corruption issues were from the past, and as Bédié had ascended to the presidency, it was inappropriate for us to publish the story. Since Bédié became the head of the state, fourteen journalists have been arrested. But we were able to publish, although they threatened that at any moment they could throw us in jail. In French there is a sentence that says that when you are in prison there is a spear suspended above and at any moment it can fall on your head.

By this time we were writing that the president was corrupt and our stories were picked up by the U.S. press. But the government newspaper, the TV, and the radio started saying that Bédié is a blessing for our country, that he will bring good luck, and that he has been working well for us. This propaganda was too much. At that time our national soccer team played the South Africa team and the score was tied, 2-2. Everybody in the Ivory Coast was sure that this popular team, which had such great soccer players, would win the Africa Cup. The next game was on Saturday, December 16, 1995, and Bédié was at the stadium. When our team was beaten, 1-0, we joked, "He has brought bad luck to the Ivorian team." We were sentenced to two years for criminal libel.

"After eight months the president said he would pardon us, but we refused. We said, 'No, we are fighting for justice.' Release would be good but not if you can't look in your neighbor's eyes. So we stayed for four more months."

We spent a year in prison. Thanks to several organizations all over the world, the Committee to Protect Journalists, Human Rights Watch, Amnesty International, and Reporters sans Frontiers, we were released after twelve months.

Naca Prison is a very hard one. It is the biggest prison in the Ivory Coast. There were six thousand inmates when we arrived and over one hundred died in detention during the first four months of 1996. We were so poor that we could never get enough to eat and constant vomiting reduced people to skeletons. You find it at Naca Prison even right now. In our case, the prisoners knew that we did not steal or kill so they had great respect for us. We were able to hold onto life in this prison because our newspaper sent us food every day. But many people were starving. They would give a small cup of rice at 8 A.M. and then nothing until the next morning, or two potatoes in the morning and then nothing until the next morning.

It's funny that the Ivorian human rights league was continuously denied access to the prison until the 1992 demonstrations, when one of its members, a law professor, was imprisoned for seven months. He said, "You see—I've always been telling you I would like to see the prison and now I finally got access."

In the prison there are different categories. We were In a building for government officials and Europeans. Our publisher and two other journalists and I shared a four-person cell. The prisoners respected us and the guards tried to be helpful.

After eight months the president said he would pardon us, but we refused. We said, "No, we are fighting for justice." Release would be good but not if you can't look in your neighbor's eyes. So we stayed for four more months.

I have three children—two daughters and a son who is two and a half. When Atika was eight months old, his mother took him to Cameroon. But she sent him home and he arrived the very day I was arrested. My daughters were in the house with my brothers when I was arrested. The oldest is fifteen and the second is eight. I had to find somebody who could take care of the baby. It took four or five days. I didn't want people to think I was running away from my trial because it would have been a big shame. The judge said he was going send me to Naca Prison but he would give me one week to get everything in order.

Several countries in Africa are like the Ivory Coast. You have two opportunities: fight for human rights and prepare a good future for your kids, or choose to bend and do what the party decides. So you take care of your family, you go on working doing what you have to do. But when they arrest you, you can die. So you better fight so your children will have a good future.

I tell my children that at any moment I can die. It is better to know. And I tell them, too, that at any moment I can be arrested. I wish my work didn't have a negative impact on my children. But I know that if I want a good future for them we must struggle, each of us, in our own way.

Resource Guide: When two addresses are listed, the first is for personal contact; the second for further information.

ANONYMOUS
c/o Robert F. Kennedy Memorial Center for Human Rights
Contact: Steve Rickard
(Director of the Center for Human Rights)
1367 Connecticut Ave. NW Suite 200
Washington DC 20036 USA
T: 202-463-7575 / F: 202-463-6606
http://www.rfkmemorial.org

HAFEZ AL SAYED, MOHAMMED AHMAD SEADA
8/10 Mathaf El Manial St. 10th Floor
Manial El Roda
Cairo, Egypt
T: 20-2-363-6811 or 20-2-362-0467
F: 20-2-362-1613
E-mail: cohr@link.com.eg or cohr@idsc.gov.eg

The Egyptian Organization for Human Rights
Contact: Youssri Mustafa (Executive Director)
8/10 Mathaf El Manial St. 10th Floor
Manial El Roda
Cairo, Egypt

ARIAS SÁNCHEZ, OSCAR
Arias Foundation for Peace and Human Progress
Apartado 8-6410-1000
San José, Costa Rica
T: 506-255-2955 / F: 506-255-2244
E-mail: info@arias.or.cr
http://www.arias.or.cr

BUJAK, ZBIGNIEW
05-822 Milanowek
ul. Wysoka 1
Poland

HIS HOLINESS THE DALAI LAMA
c/o The Office of Tibet
Ngawang Rabgyal
Representative of His Holiness the Dalai Lama
241 East 32nd St.
New York NY 10016 USA
E-mail: otny@peacenet.org

International Campaign for Tibet
Contact: Bhuchung Tsering
1825 K Street NW #520
Washington DC 20006 USA
E-mail: ict@peacenet.org
http://www.savetibet.org

DOGBADZI, JULIANA
c/o International Needs, Ghana
P.O. Box 690, Dansoman
Accra, Ghana
T: 233-21-226620 / F: 233-21-226620
E-mail: itneeds@ghana.com

International Needs Ghana
Contact: Vincent Azumah
P.O. Box 690, Dansoman
Accra, Ghana

GALABRU, CHHIV KEK
#103, Street 97
Phnom Penh, Cambodia
T: (855) 12-802-506
F: (815) 550-4474
E-mail: lincadho@camnet.com.kh

GARZÓN REAL, BALTASAR
C/ Escorial, #16 - 2B
Madrid, Spain 28004
T: 91-523-0951
F: 91-523-2943

Fundación de Artistas e Intelectualas
por los Pueblos Indígenas de Iberoamerica
Contact: Adriana Arce
C/ Escorial, #16 - 2B
Madrid, Spain 28004
http://www.funindioander.es

GOMBOS, GABOR
31 Klauzal Street
Budapest, Hungary H-1072
T and F: 361-268-9917
E-mail: gombosg@mail.matav.hu

Mental Health Interest Forum
Contact: Gábor Gombos
Szigony Street 13A
Budapest, Hungary H-1803

HARRIS, BRUCE
Casa Alianza, Apartado 1734-2050
San Pedro, Costa Rica
T: 011-506-253-5439 / F: 011-506-224-5689
E-mail: info@casa-alianza.org
http://www.casa-alianza.org

HAVEL, VACLAV
Office of the President of the Czech Republic
Contact: Ladislav Spacak
Prague Castle
Postal Code 11908
Prague 1 Czech Republic
T: 00420-2-2437-1111
E-mail: President@hrad.cz
http://www.hrad.cz

HUSSEINI, RANA
P.O. Box 830199, Amman
11183 Jordan
T: 96279-545776 / F: 9626-5682735
E-mail: ranahuss@nets.com.jo

HSAW WA, KA
EarthRights International
2012 Massachusetts Avenue NW
Suite 500
Washington DC 20036 USA
http://www.earthrights.org

JAHANGIR, ASMA AND JILANI, HINA
131-E/, Gulberg-III,
Lahore-Pakistan
T: 92-42-5763-234-5 / F: 92-42-5763-236
E-Mail: asmalaw@brain.net.pk

Human Rights Commission of Pakistan
Contact: Mr. I. A. Rehman
HRCP 107 Tipu Block
New Garden Town, Lahore-Pakistan

JIMÉNEZ FLORES, PATRIA
Closet de Sor Juana
Nevado 112 Departamento 8
Mexico DF 03300 Mexico
T: 525-672-7623 / F: 525-420-1762
E-mail: Patriaj@hotmail.com

JONES, VAN
Ella Baker Center for Human Rights
P.M.B. 409
1230 Market Street
San Francisco CA 94102 USA
T: 415-951-4844 / F: 415-951-4813
E-mail: humanrts@ellabakercenter.org
http://www.ellabakercenter.org

KANDIC, NATASA
Belgrade, Avalska 9
11000 Serbia, FR Yugoslavia
T: 381-11-444-5741 / F: 381-11-444-3944
E-mail: hlc_nk@eunet.yu

Humanitarian Law Center
Avalska 9, Belgrade
11 000 Belgrade, FR Yugoslavia
http://www.hlc.org.yu

KASSINDJA, FAUZIYA
c/o Equality Now
P.O. Box 20646
Columbus Circle Station
New York NY 10023 USA
T: 212-586-0906, F: 212-586-1611
Info@equalitynow.org
http://www.equalitynow.com

MAATHAI, WANGARI
Greenbelt Movement
P.O. Box 67545
Nairobi, Kenya
T: 254-2-571523 or 603867
F: 254-2-504264
E-mail: gbm@inconnect.co.ke

MENCHÚ TUM, RIGOBERTA
Fundación Rigoberta Menchú Tum
Contact: Claudia Virginia
1ª Calle 7-45 Zona
01001 Guatemala
T: 502-254-5840 / F: 502-254-4477
E-mail: rmt@infovia.com.gt
http://ourworld.compuserve.com/homepages/rmtpaz

MÉNDEZ, JUAN
140 Notre Dame Law School
Notre Dame IN 4530 USA
T: 219-631-7895
F: 219-631-8702
E-mail: Juan.E.Mendez.5@nd.edu

Centro de Estudios Legales y Sociales
Contact: Martín Abregú
Rodríguez Peña 289
1025 Buenos Aires
Argentina

MULLER, BOBBY
2001 S Street NW #740
Washington DC 20009 USA
T: 202-483-9222 / F: 202-483-9312

Vietnam Veterans of America Foundation
Contact: M. J. Hannett
2001 S Street NW #740
Washington DC 20009 USA
http://www.vvaf.org

NERUDA, FREEDOM
E-mail: gnh@africaonline.com.ci

NGEFA ATONDOKO ATOI, GUILLAUME
12 rue Dizerens, Apt. 22
1205 Geneva, Switzerland
T: 41-22-320-1074
E-mail: ngefa@hotmail.com

ASADHO
Contact: David Banza
12 Avenue de la Paix Apt.1
Kinshasa 1
Republique Democratique du Congo
T: 00243-12-21-653
E-mail: asadho@hotmailcom
http://www.congonline.com/Asadho/index.html

O'BRIEN, MARTIN
Committee on the Administration of Justice
45/47 Donegall Street, Belfast
Northern Ireland, BT1 2FG
T: 44 28 90232394 / F: 44 28 90246706
http://www.caj.org.uk

OCHOA, DIGNA
Serapio Rendon 57-B
Colonia San Rafael
Mexico, 06740, DF Mexico
T: 525-546-8217 / F: 525-535-6892
E-mail: PRODH@sjsocial.com

PRODH
Contact: Edgar Cortez
Serapio Rendon 57-B
Colonia San Rafael
Mexico, 06740, DF Mexico
http://www.sjsocial.org/PRODH/default.htm

ORTIZ, DIANNA
708 Rock Creek Church Rd. NW
Washington DC 20010 USA
T: 202-291-4371 / F: 202-256-4611
E-mail: dianna_ortiz@earthlink.net

Torture Abolition and Survivors Support Committee
(TASSC, a project of the Guatemala Human Rights
Commission/ USA)
Contact Name: Sister Dianna Ortiz OSU
3321 12th Street NE
Washington DC 20017 USA
http://www.ghrc-usa.org/

PISKLAKOVA, MARINA
ANNA Ul. Dmitriya Ulyanova
Dom 3, library 95, Moscow Russia
T: 7-095-135-1163, F: 7-095-335-96-48
E-mail: marina@emeraldgp.com

At ANNA: Contacts: Marina Pisklakova,
Elena Potapova, or Andrei Sinelnikov
Emerald Institute for International Assistance
699 Hampshire Road, suite 204
Westlake Village CA 91361 USA
T: 805-374-1272 / F: 805-374-1274

PREJEAN, SISTER HELEN
Sister Helen Prejean
3009 Grand Rte., St. John #5
New Orleans LA 70119 USA
T: 504-948-6557 / F: 504-948-6558
E-mail: hprejean@aol.com

PRIETO MENDEZ, JAIME
Paulo VI, Bloque C-3, Apto.408
Santafé de Bogotá, Colombia
F: 57-1-221-16-47
E-mail: Prieto_jaime@hotmail.com

Comité de Solidaridad con los Presos Políticos
Contact: Augustin Jiménez Cuello, Presidente,
or Flor Múnera, Tesorera
Avenida Jiménez #8-49, of. 10-01
Santafé de Bogotá, zona postal 1, Colombia
T: 57-1-243-71-56, 57-1-282-49-64
F: 57-1-243-72-93
E-mail: fcspp@colnodo.apc.org

RAMOS-HORTA, JOSÉ
P.O. Box 651
Nightcliff, Darwin NT 9814 Australia
E-mail: etiscaus@downunder.net.au

International Support Center
Contact: Dr. Juan Federer
P.O. Box 651
Nightcliff, Darwin NT 9814 Australia
http://www.easttimor.com

SARIHAN, SENAL
Association of Women
Mesrutiyet Caddesi 20-3
06650 Kizilay Ankara, Turkey

SATYARTHI, KAILASH
Mr. R. S. Chaurasia
73 Aravali Apartments, Alaknanda
New Delhi, 110019 India
T: 91-11-6489855, 6480254, 6224899, 6475481
F: 91-11-6236818
E-mail: kailashsatyarthi@hotmail.com

South Asian Coalition on Child Servitude (SACCS)
Contact Name: R. S. Chaurasia
L-6, Kalkaji, New Delhi 110019 India

SOBERÓN, FRANCISCO GARRIDO
JR. Pachacutec 980 – Jesus Maria
Lima, Peru
T: 51-1-4247057, 4310482, 4314837

F: 51-1-4310477
E-mail: fsoberon@aprodeh.org.pe
Asociación Pro Derechos Humanos
http://www.aprodeh.org.pe

SOURANI, RAJI
Palestinian Center for Human Rights
Gaza
Omar El Mukhatar St.—Qadada Building
P.O. Box 1204
T: 07-282477 / F: 07-2825893

STREMKOVSKAYA, VERA
6 Kedyshko str, apt. 47
220012 Belarus
T: 35717-266-2570
E-mail: vera@nsys.by

SULTAN, ABUBACAR M.
Rua da Alegria, 166, PO Box 2935
Maputo, Mozambique
T: 258 1 309664 or 258 82 304932
E-mail: asultan@teledata.mz

Wona Sanana Project—Fundacao para o
Desenvolvimento da Comunidade
Contact: Abubacar M. Sultan
Av. Eduardo Mondlane, 1270 1 andar, PO Box 2935
Maputo, Mozambique
E-mail: childdb@teledata.mz

TANRIKULU, SEZGIN
F: 90-412-221-7097

TULA, MARIA TERESA
282 Baker Street East
St. Paul MN 55107 USA

TUTU, ARCHBISHOP DESMOND
Contact: Mrs Lavinia Browne
PO Box 3162
Cape Town, South Africa 8000
T: 27-21-424-5161
F: 27-21-424-5227

VIET HOAT, DOAN
4908 Ravensworth
Annandale, VA 22003 USA
T: 703-256-0277 / F: 703-256-0918
E-mail: thuctran@aol.com

International Institute for Vietnam
Contact: Pham Trinh Cat
http:// www.vietforum.org

WA WAMWERE, KOIGI
Røyskattveien 4B
1413 Tårnåsen Norway
T: 47-66804513 / F: 47-66804513
E-mail: wamwere@online.no

Kenya Human Rights Initiative
Contact: Michael Koplinka
E-mail: khri@cornell.edu

WEI JINGSHENG
Center for the Study of Human Rights
Mail Code 3365,

Columbia University
New York, NY 10025 USA
T: 212-854-4817 / F: 212-854-8050
E-mail: jswei1950@aol.com
http://www.cc.columbia.edu/cu/humanrights

WIESEL, ELIE
Boston University
745 Commonwealth Avenue
Boston MA 02215 USA
T: 617-353-4566 / F: 617-353-4024

WISSA, HIS GRACE BISHOP
Coptic Orthodox Bishopric
Al Baliana, Sohag Egypt
T: 02-93-800-816 / F: 02-93-801-312
E-mail: Hgbwissa@aol.com

Center For Religious Freedom
Contact: Nina Shea
1319 18th Street, NW
Washington DC 20036 USA
http://www.freedomhouse.org/religion

WOODS, SAMUEL KOFI
Merwedestraat 4
2515 TR Netherlands
T: 31-70-381-80-58 / F: 31-70-381-80-58
E-mail: Samuelwoods@hotmail.com

Forefront
Contact: Lesley Carson
333 Seventh Avenue, 13th Floor
New York NY 10001 USA

WRIGHT EDELMAN, MARIAN
President and Founder
Children's Defense Fund
25 E Street NW
Washington DC 20001-1591 USA
T: 202-628-8787 / F: 202-662-3510
E-mail: cdfinfo@childrensdefense.org
http:// www.childrensdefense.org

WU, HARRY
Laogai Research Foundation
888 16th Street NW Suite 5310
Washington DC 20006 USA
T: 202-508-8215 / F: 202-955-5486
E-mail: laogai@laogai.org
http://www.laogai.org

YUNUS, MUHAMMAD
Managing Director
Grameen Bank
Mirpur, Dhaka 1216 Bangladesh
T: 880-2-801-1138 / F: 880-2-801-3559
E-mail: Yunus@grameen.net
http://www.grameen-info.org

Grameen Foundation USA
Contact: Alex Counts (President)
1709 New York Avenue NW Suite 101
Washington DC 20006 USA
T: 202-628-3560 / F: 202-628-380
E-mail: acounts@grameenfoundation.org
http://www.grameenfoundation.org

ZALAQUETT, JOSÉ
Fax: 56-2-209-76-39
E-mail: jzalaque@reuna.cl

Additional organizations to contact for information, contributions, and action:

ROBERT F. KENNEDY MEMORIAL CENTER FOR HUMAN RIGHTS
1367 Connecticut Avenue N.W.
Washington D.C. 20036 USA
T: 202-463-7575
F: 202-463-6606
E-mail: info@RFKmemorial.org
http://www.Rfkmemorial.org

AMNESTY INTERNATIONAL
322 Eighth Avenue
New York, New York
10001-4808 USA
T: 212-807-8400
F: 212-627-1451
http://www.amnesty-usa.org

HUMAN RIGHTS WATCH
350 Fifth Avenue 34th Floor
New York, New York 10118-3299 USA
T: 212-290-4700
F: 212-736-1300
E-mail: hrwnyc@hrw.org
http://www.hrw.org

LAWYER'S COMMITTEE FOR HUMAN RIGHTS
333 Seventh Avenue 13th Floor
New York, New York 10001 USA
T: 212-845-5200
F:212-845-5299
E-mail: nyc@lchr.org
http://www.lchr.org

WITNESS
E-mail: nyc@lchr.org
http://www.witness.org

FOREFRONT
E-mail: nyc@lchr.org
http://www.forefront.org

COMMITTEE TO PROTECT JOURNALISTS
330 Seventh Avenue, 12th Floor
New York, New York 10001 USA
T: 212-465-1004
F: 212-465-9568
http://www.cpj.org

U. S. DEPARTMENT OF STATE
Bureau of Democracy, Human Rights and Labor
21st and C Streets NW.
Washington DC 20520 USA
F: 202-647-9519
http://www.state.gov

ACKNOWLEDGMENTS

Speak Truth to Power was created with the help of many. I am most grateful to all the defenders who took the time to participate in this project, for sharing their lives, their time, their innermost thoughts. What started out as a survey became, ultimately, a spiritual journey about the power of one.

This book was a collaborative effort. I want to thank Eddie Adams for all the time, effort and energy he devoted to this project, and for going forward when the going got rough. Alyssa Adams played an invaluable role in keeping us on track. Melissa LeBouef spent countless hours setting up photo shoots with people who were difficult to reach in far-off lands at all hours of day and night in a multitude of languages, remaining cheerful and efficient throughout, even when the rest of us were not. Carrie Trybulec spent over a year sending letters and proposals, setting up interviews, making phone calls, speaking with airlines and travel agents, and performing all sorts of other painstaking work, then watched my children so I could write. Carrie, this book is in great part a result of your efforts and sacrifice, and you have my eternal gratitude.

Ever since 1981 when Amnesty International granted me a summer internship, I have been blessed by the opportunity to meet and work with the foremost human rights defenders of our time, many of whom are included in this book. Other old friends and leaders in the field might not be found among these pages, but their vision and influence are well represented here, as I relied on their invaluable advise for countries, issues, and champions to include in the work. I am especially grateful to Michael Posner who was always there for me, day and night, and who put the entire staff of the Lawyers' Committee for Human Rights at my disposal. Many thanks to Lili Brown, Camille Massey, Mary Morris, and all your colleagues. Bill Schulz of Amnesty International USA was of invaluable help, as were Maina Kiai in London and Steve Rickard, Carlos Salinas, and Adotei Akwei in Washington. Ken Roth and the staff of Human Rights Watch gave valuable assistance, as did Anne Cooper and the staff of The Committee to Protect Journalists, and Lodi Gyari, John Ackerly, Tenzin Thakla, Lesley Friedell, and the staff of the International Campaign for Tibet. I am grateful to all those who helped with research and who facilitated meetings, including John Allen, Mike Amitay, Joseph Assad, Vincent Azumah, Holly Bartling, Layli Miller Bashir, Stefan Beltran, Michelle Bohana, Lesley Carson, Lili Cole, Wilson DaSilva, Pat Davis, Robert Drinan, Peter Edelman, Joe Eldridge, Frank Ferrari, Lynn Frederickson, Yael Fuchs, Ellen Hume, Suzie Jakes, Michael Kennedy, Kasia Kietlinska, Diamond Liu, Marysia Ostafin, Katie Redford, Eric Rosenthal, John Shattuck, Brenda Shelton, Gare Smith, Jean Kennedy Smith, Jane Spencer, Valerie Thomas, and Alice Zachman. To transcribe the interviews, I called upon friends and friends of friends, and in a volunteer network that made this book possible on a shoestring budget. Thanks to Kelly Fagen Altmire, Eleana Ditanna, Itzel Fairley, David Gross, Suzy Wills Kelly, Alicia Kochar, Michele Nelson, Denise Oliviera, Virginia Stevens, Heather Troup, Brian Turetsky, and Annelle Urriola. My dear friend Lynne O'Brien took up the arduous task of identifying and organizing the transcribers for the last five months of the project, transcribing many herself, and her enthusiasm and efficiency were vitally important throughout; thank you, Lynne.

Transcriptions finished on each interview, I edited them, then sent them on to Nan Richardson. Our friendship spans a quarter century, and it is difficult to describe how central Nan was to the production of this project. When I conceived the idea, Nan was the first person I turned to, and her enthusiasm inspired me to write a proposal. Her remarks on that proposal readied it for presentation to Random House. Nan suggested I use her agent, Sarah Chalfont, at the Andrew Wylie agency to negotiate the deal, which Sarah did with tremendous positive energy, standing by the project at every turn in the road. Nan was there also, with me every step of the way, editing my edits of the interviews, waiting patiently for my re-edits, and then editing again, and returning them to me. Each transcription went through a minimum of eight edits, sometimes more. Original versions of several interviews were over thirty pages long; narrowing them down to a core four or five pages while retaining the most compelling material required imagination and sensitivity. I relied on Nan's judgment throughout. Having never written a book before, I was blissfully unaware of the complexities of the publishing industry and the requirements for actual production of a photography book. Nan took responsibility for layout, design, and production, and without her insider's knowledge, dogged determination, and supreme organizational skills, this book would never have been produced with such care and timeliness, and for that I thank her. When we ran into difficulty, Nan was always reliable and fair. Nan, for all your help and support throughout, thank you.

Sincere thanks to assistant editor Camille Robcis, who worked on this night and day, tracking people to the ends of the earth and keeping a thousand details in order, when chaos seemed to reign, and to the rest of the staff at Umbrage, including Sophie Fenwick, Lesley Martin, and especially Elaine Luthy for her impassioned copyediting expertise. Thanks to Yolanda Cuomo and Kristi Norgaard for

strong and inspired design, and endless enthusiasm, and to Mondadori, especially Nancy Freeman, for their great printing job and generousity holding costs. I am grateful at Crown to Philip Turner, who believed in this book through thick and thin; to Doug Pepper, who took over at another critical juncture and ran it to the end; to Steve Ross, who stood up and said yes when no would have been so much easier; to the excellent and energetic Teresa Nicholas, director of production; and to marketing and publicity experts Rachel Pace and Tina Constable who threw their considerable combined force into the effort. Thanks also to Peter Bernstein whose vision allowed the project to go forward.

Our warm appreciation for their assistance in organizing a spectacular exhibition goes to Tracy A. Quinn, Cissy Foote Anklam, and Cara Sutherland of the Newseum for their enthusiasm and energy in kick-starting this effort, and their determination in seeing it through, and to Charles Overby and John Siegenthaler of the Freedom Forum for their support. In the theater presentation thanks first to Ariel Dorfman for his superlative efforts in making a true drama out of these interviews, and his agent Peter Hagen for his support. Larry Wilker and Elizabeth Thomas at the Kennedy Center for taking on the premiere; director Greg Mosher for his vision for the production, one of his frequent human rights contributions.

The cost of making this book and the related materials far exceeded the actual funds available for completion, and many participated in making its existence possible. I am most grateful to Daniel Abraham, Elliot Broidy, Peter L. Buttenwieser, Matt Gohd, David and Storrie Hayden, Sidney Kimmel, Alexandra, Teddy, and Audrey King, Mary and Steven Swig, Cheryl and Hani Masri, Vardis and Marianna Vardinoyannis, for their personal generosity; Elizabeth and Smith Bagley at the Arca Foundation, Eunice Kennedy Shriver at the Joseph P. Kennedy, Jr. Foundation, Paul and Phyllis Fireman at the Paul and Phyllis Fireman Fund, Peter B. Kovler at the Marjorie Kovler Fund, along with Doug Cahn, Sharon Cohen, and Paula van Gelder at the Reebok Foundation, and Debbie Dingell at the General Motors Foundation. In addition, we relied heavily on in-kind donations from a number of generous supporters. At the Robert F. Kennedy Memorial, Dean Smith first saw the value of sponsoring the project while Lynn Delaney allowed me to call upon the staff of the R. F. K. Center for Human Rights whenever I needed their help; Fran Warring created meticulous records out of thousands of scraps of paper from countries and currencies too numerable to mention. Thanks to R. F. K. staff members Abigail Abrash, Josefina Harvin, Carrie Heitmeyer, Margaret Huang, David Kim, Anjali Kochar, Alex Mundt, Margaret Popkin, Stephen Rickard, Kimberly Stanton, and James Silk. At Coudert Brothers, the kindness, generosity, and wise counsel of Anthony Williams kept this project out of trouble and on track; my sincere gratitude to him and to his indefatigable assistant, Lee Stiles. At United Airlines, Joe Laughlin came through with wings to remote places, sometimes at the eleventh hour, like the prince he is. Also thanks to Anne Costello, Anne Wexler, and Bernie Willett at American Airlines, to the Edelman Public Relations Worldwide, to Fred Malek at Marriot, to Bob Burkett at Northwest, to Christopher Hunsberger at the Four Seasons in Washington D.C., and for facilitating the Starwood Westin Palace, Madrid, Christopher Evans and David Stein.

I would also like to thank Marcel Saba of the Saba Agency for offering help when we really needed it; Joel Solomon for organizing the Mexico trip as well as transcribing and translating for Digna Ochoa and Patria Jiménez; Charlie Roberts for translating for Jaime Prieto and Maria Teresa Tula, and the ARTI transcribers for their excellent work. A special thanks to those whom we hoped to include in the book until oceans and time proved obstacles we could not overcome for this edition, namely Olissa Agbakoba of Nigeria, Willy Mutunga of Kenya, Jacqui Katona and Yvonne Margarulas of Australia, Zazi Sadou of Algeria, and Bambang Widjojanto of Indonesia. A very special thanks to Moulud Said who worked so hard to facilitate access to his people, the Sahrawi of Western Sahara. To the women in Algeria, I deeply regret that your government yanked our visas hours before arrival and we therefore missed hearing your stories; similar regrets are extended to those in Kosovo, Rwanda, and Chechnya, who we hoped to include here—someday we will work together. Writing this incomplete list makes me realize how blessed I am to be involved in human rights, in work so compelling that it naturally creates an expansive support network. We are not alone. Thanks to you all. I am blessed by extraordinary friends and family whose love and support sustain me, and who put their many resources at my disposal, especially Susan Blumenthal, Chris Downey, Beth Dozoretz, Rhoda Glickman, Ethel Kennedy, Rory Kennedy, and Mary Richardson Kennedy.

Albert Camus said, "In the depth of winter, I finally learned that within me, there lay an invincible summer." My love to three little girls who never fail to show me all the joys of summer: Cara, Mariah, and my smallest companion, Michaela, who sat on my knees or hid beneath my desk as I typed; and to Andrew, whose work to make America the land it must be, inspires.

—KERRY KENNEDY CUOMO

ACKNOWLEDGMENTS

I would like to acknowledge Melissa LeBoeuf for producing this project over the past three years, for her hundreds of phone calls, late hours, finesse in logistics, her refusal to accept the word no for an answer, for scheduling fifty photoshoots worldwide, and for her unwavering and untiring dedication—I thank you. I would like to thank my wife, Alyssa Adams, for her photo editing skills and for her help in pushing this project during its final stages.

I would like to take this opportunity to thank the people who have opened doors for me during my career, giving me the breadth of experience as a photographer and a person, laying the foundation to make this project attainable to me as a photographer: Walter Anderson of *Parade* Publications; Hal Buell, Keith Fuller, Lou Boccardi, and Wes Gallagher, all of the Associated Press; and John Durniak and Arnold Drapkin of *Time* magazine. I also want to thank The Eddie Adams Photojournalism Workshop board of directors for their continued support over the past thirteen years and their shared belief that one photographer can make a difference: Vince Alabiso, Larry Armstrong, Adrienne Aurichio, Hal Buell, Barbara Baker Burrows, James Colton, Dave Einsel, Steve Fine, John Filo, Maura Foley, Mayanne Golon, Tom Kennedy, Kent J. Kobersteen, Eliane Laffont, Nancy Lee, Richard LoPinto, M.C. Marden, Carl Mydans, Gordon Parks, Joe Rosenthal, Kathy Ryan, Patrick T. Siewert, and Michele Stephenson.

My sincere acknowledgments to Kodak Professional Division for their Tri-X Pan film used in making these images and to the following manufacturers for the cameras used in creating these portraits: Nikon (for the F5), Mamiya (for the RZ67), and Contax (for the Contax 645). A special thank you to Richard LoPinto, Bill Pekala and Sam Garcia of Nikon, and Henry Froelich and Jan Lederman of Mamiya for their continued technical support and friendship. A much-appreciated thank you to both George Smol and Charles Griffin who printed the pictures for book and exhibition, respectively, under a tight deadline.

To my first family, thank you to my children, Amy, Susan, and Edward and their mother, Ann. To my youngest, everyday, at least once, I'll embrace my ten-year-old son, August. I'll look into his sparkling blue eyes and say, "I love you!" Thank you, my son, for your inspiration and confidence.

And a very special "thank you" to the unknown soldiers without guns—I salute you.

—EDDIE ADAMS

Speak Truth to Power, the multi-media exhibition of photographs,

will open on September 19, 2000, at The Corcoran Gallery, Washington, D.C.,

and travel internationally from 2001 to 2004 thereafter,

beginning with the following venues:

The Newseum, New York, New York

The Museum of Contemporary Photography, Chicago, Illinois

Published by Crown Publishers, New York

Member of the Crown Publishing Group

Random House, Inc. New York, Toronto, London, Sydney, Auckland

www.randomhouse.com

CROWN is a trademark and the Crown colophon is a registered trademark of Random House, Inc.

Printed in Italy by Mondadori Printing

ISBN 0-812-93062-2

10 9 8 7 6 5 4 3 2 1

First Edition

Library of Congress Cataloging-in-Publication Data

is available upon request.

Produced and edited by: Umbrage Editions, Inc.

515 Canal Street, New York, New York 10013

www.umbragebooks.com

Editor: Nan Richardson

Associate Editor: Camille Robcis

Assistant Editor: Sophie Fenwick

Consulting Editor: Lesley A. Martin

Editorial Assistants: Anna Nordberg, Deborah Apsel,

Abby Stoller, LauraBeth Bravo, Tim Bazzle

Associate Designer: Kristi Norgaard

Copyeditor: Elaine Luthy

Map: Jeffrey L. Ward Graphic Design

Please visit our Web site at: www.SpeakTruthtoPower.org

Book Design: Yolanda Cuomo Design, NYC